CHANGE AND CONTINUITY

An Exhibition in the

Heafitz Hall of the North American Indian

Acknowledgments

The Hall of the North American Indian, and the accompanying catalogue, owe their execution and completion to the dedicated efforts of the following:

Consultants: Lawrence Bauer, Bruce Bourque, Elizabeth Buckley, James Deetz, Delores Delaittre, William Fitzhugh, Catherine Fowler, Bette Haskins, Bruce Heafitz, Karen Heafitz, Bill Holm, Eleanor Leacock, Joan Lester, Margot Liberty, Hartman Lomawaima, Alfonso Ortiz, Bruce Smith, William Sturtevant, James VanStone, William Wallace, Wilcomb E. Washburn, Joe Ben Wheat, Ruth Holmes Whitehead, Stephen Williams, and Yvonne Wynde.

Curatorial Research Assistants: Judith Habicht-Mauche and John Stubbs.

Past and present staff of the Peabody Museum: Melissa Banta, Kathy Bolger, Jeffrey Brain, Austin Brennan, Susan Bruce, Meg Courtney, Donna Dickerson, Madeleine Fang, Viva Fisher, Scott Fulton, Michael Gesclowitz, James Gilmore, Gloria Greis, T. Rose Holdcraft, Daniel Jones, Martha Labell, Barbara Mangum, Beryl Noble, James Robertson, Vicki Swerdlow, Kay Wedge, and Barbara Wiberg.

Interns: Jo Ellen Burkholder, Carole Dignard, Jennifer Field, Jean Fritts, Stephen Green, Pablo Lopez, and Sara Walser.

Assistants: Christina Behrmann, Alexander Frankfurter, Elizabeth Gibson, Michael Grassi, Joeanna Hill, Ross Jolly, Thea Milder, Dennis Piechota, Jane Drake Piechota, Helen Robbins, Hamish Shorto, Peter Szysko, and Sam Tager.

Work Study: Anca M. Achim, Amy Brooks, Rosanna Castillo, Shuma Chakravarty, Paulette G. Curtis, Suzanne Colburn, John Gerry, Cynthia Hall, Jane Iwamura, Eric Kjellgren, Mark Meyerrose, Zoe Mulford, Amanda Nourse, Amy Raymond, Roxanne Reddington-Wilde, Lee Nathaniel Saffel, Susan Shumaker, Scott Snyder, and T. Lynn Stott.

Volunteers: Charity Appell, Frederica Dimmick, Byron Harvey, Mielle Harvey, Sara McGregor, Barbara McCue, Martha Richardson, Sylvia Vaterlaus, and Shirley Weinberg.

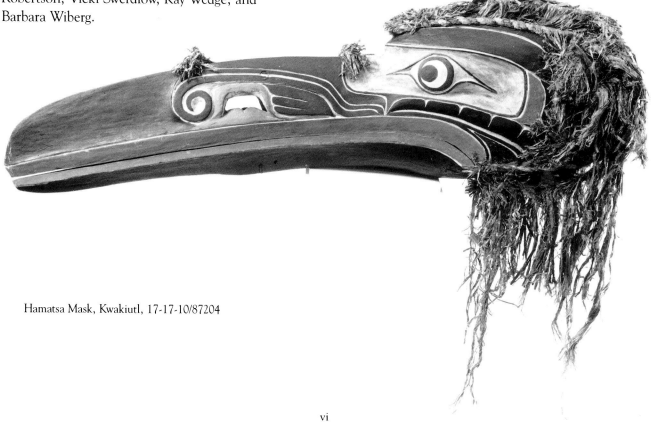

Hamatsa Mask, Kwakiutl, 17-17-10/87204

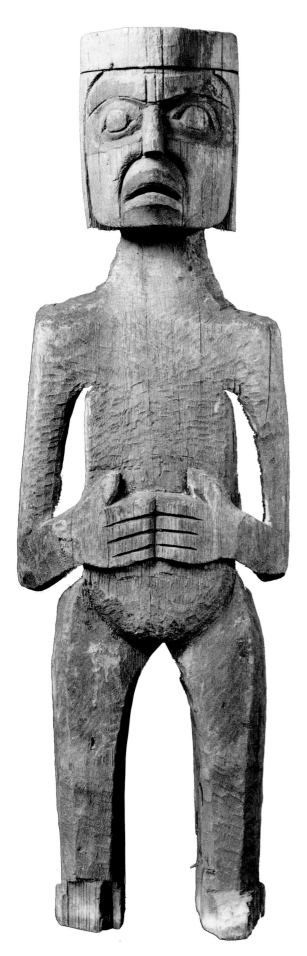

The Hall of
The North American Indian

The Watcher for Guests

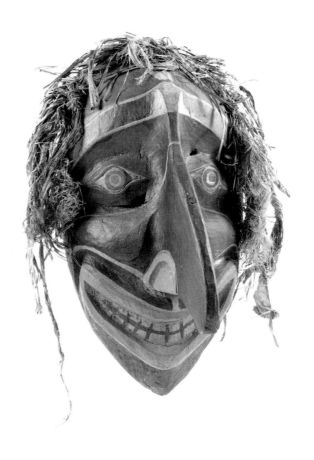

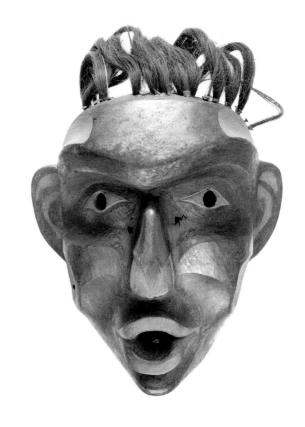

Previous page, *The Watcher for Guests*
Kwakiutl, 17-17-10/87186

Above right, Noohlmahl Mask
Kwakiutl, 17-17-10/87207

Below right, Dzoonokwa Mask
Kwakiutl, 17-17-10/87188

ii

The Hall of
The North American Indian

CHANGE AND CONTINUITY

Photographs by Hillel S. Burger

Ethnographic Annotation by Ian W. Brown
Edited by Barbara Isaac

Foreword by C. C. Lamberg-Karlovsky
Contributions by J. J. Brody, Ian W. Brown, Bill Holm, and Wilcomb E. Washburn
Exhibit design by Richard V. Riccio

Peabody Museum Press, Cambridge, Massachusetts 1990 Distributed by Harvard University Press

Contents

Foreword

In two years we will be celebrating one of the great transforming events in human history, the discovery of the New World. With this discovery our planet, and human consciousness, were forever changed. This event cannot be celebrated without some sense of shame, given the tragic consequences for the native populations, which upon contact were decimated by disease and later by wars of outright genocide. In spite of this tragic history the Native American has persevered and holds a special fascination throughout the world. We seldom realize the extent of global interest in the native populations of this continent. When I was a young boy in Czechoslovakia I read for the first time of the exploits of Meriwether Lewis and William Clark among the Mandan Indians of the Missouri Valley. The book was one of an almost countless number of pulp paperbacks available in Czechoslovakia on the American frontier and the ensuing clash of cultures.

Today the Peabody Museum exhibits not only some of the unique materials collected by Lewis and Clark but a full complement of artifacts from each of the major culture areas of the Native American people. This exhibition, in the largest gallery of the museum, places before the public one of the finest ethnographic collections in this country. The task of selecting from well over 100,000 ethnographic objects pertaining to North America in the collections of the Peabody was beyond daunting. The selected objects address our theme, "Change and Continuity," and are meant to inform the visitor of the rich complexity, variation and integrity of the North American Indian cultural traditions.

This exhibit has been five years in the making. It has involved over a dozen Native Americans and academic consultants as well as the entire museum staff. Unlike many exhibits, our task went far beyond the selection of materials to address a particular theme. The entire gallery was physically gutted and reconstituted with new exhibit cabinets, lighting systems, security devices, and temperature control systems. Quite simply stated, it is the largest endeavor devoted to the exhibition of Peabody Museum collections since the construction of the museum 124 years ago. Such an endeavor could not have been accomplished without the coordination and collaboration of a very considerable number of people.

In this my twelfth and final year as Director, it gives me personal pleasure to extend my gratitude to all those who made this endeavor a successful reality. The individuals named below are but a few of the small but committed Peabody staff that made the past dozen years a memorable experience. Dr. Garth Bawden, now Director of the Maxwell Museum, University of Arizona, served as Assistant Director at the Peabody from 1980 to 1985 and played a fundamental role in the initial planning of this exhibit. It was during the years that Dr. Bawden served as Assistant Director that we collaborated upon and completed the total renovation of the museum's storage facility and the construction of the conservation laboratories. This modernization permitted us to move forward with the next major program: the computerization of the collections' inventory and their exhibition. Dr. Rosemary Joyce, in succeeding Dr. Bawden as Assistant Director, provided vision and commitment during the crucial years of final planning. Dr. Ian Brown as principal curator of the exhibit, and currently Assistant Director at the Peabody, was responsible for articulating, with other academic consultants, the thematic content of the exhibit, and for the selection of the objects, the preparation of the label copy, and the coordination of the entire Peabody staff in this joint effort. In short, if an exhibition were authored as a book, Dr. Brown would most clearly be its senior author. Mr. Richard Beauchamp, joined by his most competent conservation staff, reviewed the individual needs of the objects and submitted them to necessary treatment that will allow them to endure the exigencies of exhibition. Mr. Richard Riccio designed

the exhibit with a firm hand and creative imagination, placing on graphic paper the precise positions of every artifact before their installation in the display cases. His precision and conscientious commitment are abundantly complemented by his creative talents. Mr. Hillel Burger, Peabody Museum Photographer, underscores the notion that the museum's greatest asset is its human resources. Mr. Burger continues to stun the viewer with his visual images of the ethnographic object. Mrs. Barbara Isaac made available the rich resources of the museum's photographic archives, coordinated all aspects pertaining to the exhibition's visual needs, and is responsible for bringing to fruition both this catalogue and the exhibition poster. Mr. Joseph Johns, Peabody Resident Artist, known to his fellow Native Americans as Cayoni, has once again earned his reputation at the Peabody. If there appears to be an unresolvable mechanical or structural problem in the building, he and he alone is able to find a resolution to the dilemma. In addition to the above, the contributions of Ms. Lea McChesney, Ms. Kathleen Skelly, Ms. Una McDowell, and Ms. Diane Zorich are most gratefully acknowledged. Over the years numerous volunteers have offered their time and talent. This institution remains greatly indebted to their contributions.

Lastly, an exhibition with accompanying catalogue is simply not possible in the absence of a major financial commitment. This exhibition was made possible by a generous grant from the National Endowment for the Humanities. The catalogue was partially funded by a grant from the National Endowment for the Arts. In addition, the full membership of the Peabody Museum Association was solicited by our Development Office, ably staffed by Catherine Linardos and Martha Lamberg-Karlovsky. The results brought forth several hundred contributions and challenged us to sustain the confidence placed in us by the supporters of the Peabody Museum. The gift from the sons and daughter of Sylvia Heafitz and the gift from Dr. Doris Z. Stone merit special mention, for they permitted us to introduce into the Peabody Museum an exhibition worthy of one of this country's foremost collections of ethnographic material detailing Native American culture. To the entire staff of the Peabody Museum, to the contributing authors of the catalogue, and to all those whose support made the entire project possible, I extend my warmest gratitude.

C. C. Lamberg-Karlovsky
Director
April 1990

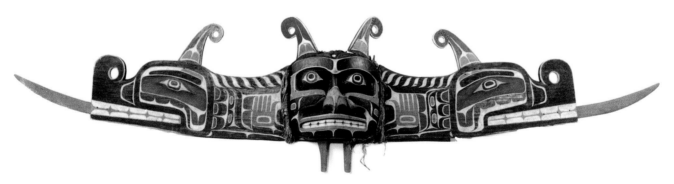

Sisiutl, Kwakiutl, 17-17-10/87206

3

Change and Continuity: Profile of an Exhibition

Ian W. Brown

Assistant Director,

Associate Curator of North American Collections,

Peabody Museum, Harvard University

The exhibition "Change and Continuity" was inspired by the idea of exploring ways in which North American Indian and Eskimo groups responded to Western contact. The idea itself is not particularly novel, but nothing quite like it had been attempted at the Peabody Museum, and so it was an exciting endeavor. "Change and Continuity" not only addresses the theme of the exhibition, but it describes the complex process of producing it. More than a hundred people have been involved in the making of this exhibition, ranging from a score of advisors, to architects, to fabricators, and to Peabody Museum curatorial, exhibitions, conservation, and collections staff. Whatever success comes of this exhibition, the credit certainly belongs to these dedicated people.

A common failure of many anthropological exhibits is the tendency to show a static picture of Native American lifeways. Depicting the Hopi in pueblos, the Navajo in hogans, and the Kwakiutl in massive plank structures certainly does provide images of the variety of adaptations, but tells us little about the complex story of *how* Native Americans came to be who they are today. By using a diachronic approach, this exhibition considers change in Native American lifeways from late prehistoric times to the contemporary scene. Because the physical environment and neighboring native populations also play a major role in the changing lifeways of all people, the "culture area" approach of arranging groups by geographical regions has been maintained in this exhibition. The major theme, however, is culture change that resulted from contact with Whites.

Although the technological predominance of Europe strongly influenced the indigenous inhabitants of North America, it is wrong to assume that all change was unidirectional. Even an item as basic as tobacco, a North American product, can be seen to have influenced the social life (and health) of populations on a global scale. On an economic level, the vast wealth of seventeenth-century Holland in large part was based on the great stock of furs transmitted from the Indians of the Eastern Woodlands. The desire for these resources could only have been satisfied by close and constant contact with the Indians. Control of North America was an integral aspect of the century of wars fought between France and England in the eighteenth century, and Indians played a significant role in the various outcomes.

It is often easier to see the influence of Western civilization on Native American societies because of its marked impact on material culture. In any culture contact situation, people pick and choose introduced objects or ideas which can be integrated into their lives. But often the introductions are reinterpreted so that they no longer have the same function or meaning as they had in the donor society. Cutting up a brass kettle into dozens of fragments that then serve as ornaments is an example of this change in function. However, when metal replaced stone in the manufacture of points, scrapers, awls, and other tools, it was not a mere matter of substitution. The loss of a technology such as stoneworking, which had existed on this continent for millennia, had an important effect on native economy. An increasing dependency on the intruders for replenishment of materials was a major negative effect of culture contact.

Change is a difficult concept to deal with because of the nature of "time" and its interpretation. E. E. Evans-Pritchard in his ethnography on the Nuer, a tribal group in Africa, distinguishes between the different levels of time that exist in non-Western societies (1940). His detailed analysis of the concepts of ecological time (relating to the environment) and

structural time (relating to social structure) are reminders that "Western time" is only half of the total perspective. As seen in the writings of the contributors to *The American Indian and the Problem of History* (Martin 1987), it is dangerous to apply a European sense of temporal structure to Native American world view. Although we do use time lines throughout the exhibition to provide viewers with a temporal framework to assess change, it should be emphasized that the Native Americans who were experiencing the changes would not have viewed time in the same way as the Whites did.

It cannot be denied that the overall complexion of culture contact in North America is negative. The rapid spread of infectious diseases was the prime atrocity (Crosby 1976). Epidemics wrought such havoc on the inhabitants of the Americas that for most areas "virgin land" was really "widowed land." The deleterious effects of such epidemics are dealt with throughout the exhibition, as are other negative aspects of contact, especially the conscious genocide of a people. In many areas of North America the intruder's approach was to destroy or drive out the competitors. As long as Indians were the link to the desired resources (like furs), they were exploited, but when they became an impediment (as in land competition), they were exterminated, put on reservations where they could be controlled, or removed to other portions of the country. This is the dark side of contact that is brought home to the viewer throughout the exhibition.

On the bright side is the message that despite five centuries of such horror, Native Americans have survived. Culturally, the changes have been vast, but socially, they have continued to be viable members of American society. Despite the overwhelming

The Northeast section of the Hall of the North American Indian prior to 1955.

pressures put upon them, Native Americans have managed to play a very active role in the changes occurring in their lives. There can be no question that the long-range effects of culture contact with Whites inevitably resulted in demoralizing situations, but it is wrong to assume that native populations were passive recipients of change, totally unable to prevent the onslaught of new ideas and materials.

A classic example of Native American "adaptive creativity" concerns the introduction of horses and guns to the Indians of the Plains, neither of which were forced upon them. Horses and guns were accepted with enthusiasm and, once adopted, influenced most aspects of Plains lifeways (Ewers 1955; Secoy 1953). Warfare changed when small, highly mobile raiding parties replaced large groups of armored combatants. As the need for adequate pasturage became vitally important, settlement

patterns changed and mobility increased. Even social organization, art, and ceremonialism were affected by the Plains Indians' acquisition of horses and guns. But these were positive changes in that the decision-making as to how their life would alter was in the hands of the Indians. Unfortunately, the process of change is so complex that decisions to adopt certain things or ideas generally affect other aspects of life in totally unanticipated manners (Sharp 1952).

Even in situations where change was forced upon Native Americans, the nature of reaction often had a local flavor that White authorities were ill-prepared to handle. The Northwest Coast "potlatch" is an example of this situation. Historically, the main function of the potlatch was to serve as a forum to validate an individual's rights to certain positions within society. It always involved the participation of numerous people from surrounding

A display case in the Northeast area of the new exhibition.

villages and it was generally accompanied by feasting. Potlatch events were affected significantly in the mid-nineteenth century when native warfare was prohibited in British Columbia. Potlatch "wars" resulted because Northwest Coast Indians still needed to demonstrate their position in society and thus "fought with their property" (Codere 1950). When the potlatch itself was prohibited in the 1880s, the ceremony went into hiding, was disguised as a feast, or was practiced in defiance. In this example of the potlatch, the motivation for change came from an outside authority, but the Indians themselves had considerable control over the actual trajectory of the change.

Throughout the exhibition many other examples of contact are used to highlight the theme of change and continuity in Native American lifeways. It is hoped that museum-goers will gain an appreciation of how Native Americans reinterpreted and molded new concepts and materials into their cultural systems in the attempt to make the old and the new fit together. The attempts were not always successful, but they always were made.

References Cited

Codere, H.
 1950 *Fighting with Property: A Study of Kwakiutl Potlatching and Warfare, 1792–1930.* Monographs of the American Ethnological Society 18. J. J. Augustin, New York. (Reprinted by the University of Washington Press in 1966.)

Crosby, Jr., A. W.
 1976 "Virgin Soil Epidemics as a Factor in the Aboriginal Depopulation in America." *William & Mary Quarterly,* 3 ser. 33 (April):289–299.

Evans-Pritchard, E. E.
 1940 *The Nuer.* Oxford University Press, New York and Oxford.

Ewers, J. C.
 1955 *The Horse in Blackfoot Indian Culture.* Bureau of American Ethnology Bulletin 159. U.S. Government Printing Office, Washington, D.C. (Reprinted by the Smithsonian Institution Press in 1980.)

Martin, C. (ed.)
 1987 *The American Indian and the Problem of History.* Oxford University Press, New York and Oxford.

Secoy, F. R.
 1953 *Changing Military Patterns on the Great Plains.* University of Washington Press, Seattle and London.

Sharp, L.
 1952 "Steel Axes for Stone-age Australians." *Human Organization* 2:17–22.

The Newcombe Kwakiutl Collection of the Peabody Museum

Bill Holm

Curator Emeritus Northwest Coast Indian Art
Thomas Burke Memorial Washington State Museum

Among scholars of Northwest Coast art and culture, the collections of the Peabody Museum of Archaeology and Ethnology are legendary. The legatee of historically and ethnologically important collections brought to New England during the late eighteenth and early nineteenth century heyday of the Boston fur traders, the Peabody Museum houses the largest documented body of Nootkan and northern Northwest Coast material of that era in one place in North America. Equally famous and invaluable to Northwest Coast studies is the collection made in southeastern Alaska by Edward G. Fast immediately following the transfer of the territory to the United States in 1867. Fast's collection was made at the beginning of a frenzied half-century of acquisition of Northwest Coast material by the world's foremost museums (Cole 1985). Of the most active players in this game of filling the storerooms and exhibit halls of the great museums, two names stand out—Lieutenant George T. Emmons and Doctor Charles F. Newcombe— both of whom played major parts in rounding out the Peabody Museum's Northwest Coast collections in the latter days of the great collecting period. Newcombe's, and to a lesser extent Emmons', special contribution was in filling an obvious gap in the collections—the lack of material from the central Coast, especially that from the Southern Kwakiutl.

Situated for the most part around the inner shore of the northern end of Vancouver Island, the Kwakiutl people were off the beaten track of coastal exploration and travel in the early days of the maritime fur trade. The Boston men whose collections came to the Peabody Museum through early New England historical societies and museums almost never entered or tarried in the Kwakiutl country. Even after the Hudson's Bay Company established a post, Fort Rupert, in the heart of Kwakiutl territory in 1849, very little collecting was done until late in the nineteenth century, when Adrian Jacobsen and, later, Franz Boas and his invaluable local assistant George Hunt began to make systematic collections there. Thus even the largest Northwest Coast collections held very few Kwakiutl pieces with early collection dates and reliable provenience.

Some of the earliest pieces collected at Nootka Sound by traders and explorers may have been Kwakiutl, since the native people there had trading and marriage relationships with their linguistically-related neighbors across Vancouver Island via a series of trails and portages extending to the Nimkish River. And, in 1841, the United States Exploring Expedition, under Lieutenant Charles Wilkes, collected at least one Kwakiutl mask (identified as such by style and type, since it was received without documentation as a gift from a Hudson's Bay Company officer at the mouth of the Columbia River). In the 1880s and 1890s, that gap in the major collections began to be filled by the collections of Jacobsen, Boas, Hunt, Newcombe, and others, so that now the American Museum of Natural History, the Field Museum, the Canadian Museum of Civilization, the Royal British Columbia Museum, the United States National Museum of Natural History, and the Berlin Museum of Ethnography (to name some of the most prominent) count their Kwakiutl collections among their most spectacular holdings.

The Peabody entered the Kwakiutl collecting game late. In early 1917 Director C. C. Willoughby sought out the well-established collector, Dr. Charles Newcombe, to help acquire Kwakiutl items (Newcombe and Willoughby 1917). Newcombe was a Victoria, British Columbia, physician, long retired but actively engaged in collecting for many of the world's major museums. His collecting efforts had taken him all over the British Columbia coast and into southeastern Alaska, and he enjoyed the hard-won

8

confidence and friendship of many Indians. Among these native associates was Charles Nowell, a many-talented Kwakiutl from Fort Rupert who was to Newcombe as George Hunt was to Franz Boas—an intelligent, reliable, bilingual, and literate colleague, known to and respected by the people who were the potential sources of knowledge and material. It was largely through Nowell that Newcombe was able to put together in 1917 an important collection of 140 Kwakiutl ceremonial and cultural objects for the Peabody Museum.

In 1917 the Kwakiutl were in the midst of radical change. In some villages the old "big houses" were beginning to be torn down and replaced by single-family frame dwellings. Canoes carved from cedar logs, numbering in the hundreds at the turn of the century, were becoming scarce. Edward Curtis, a few years earlier, was forced to paint out a design on one of the big canoes he hired for use in his film *In the Land of the Head Hunters* in order to make it seem an additional one (Holm and Quimby 1980, pp. 55, 57). Plank-built, gas-powered boats were becoming the principal means of transportation. When Franz Boas traveled from Hope Island to Alert Bay in 1886, part of the trip was a hair-raising ride in a small hired Kwakiutl canoe under sail, a common means of transportation at the time (Rohner 1969, pp. 42–43). In contrast, by 1917 Newcombe proposed "chartering an Indian gasoline launch, which would also transport any specimens collected to the nearest steamboat wharf" (Newcombe and Willoughby 1917).

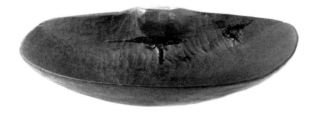

Fig. 1. Grease skimmer, Kwakiutl, 17-17-10/87104

Still, with all the changes, there were many aspects of traditional culture still alive, especially in the outlying villages. Fishing was the main means of livelihood, and many native foods were still in use, as they continue to be to this day. At Gwai'i, the isolated winter village of the Kwekwsodenokhw, Tsawadenokhw, Gwawaenokhw, and Hakhwamis

tribes, where he did much of his collecting on the 1917 trip, Newcombe bought a gracefully carved grease skimmer in the form of a large clam shell (fig. 1). This implement was made specifically for skimming candlefish oil from the surface of the simmering water in the rendering tank. Candlefish oil, or "grease" as it is called in English by Northwest Coast natives, is highly prized (and priced!) today as

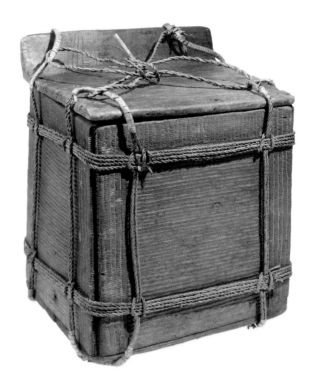

Fig. 2. Box, Kwakiutl, 17-17-10/87134

it was in Newcombe's time and before (Macnair 1971, pp. 169–171). It is made using the time-honored technique, and the carved "clam shell" skimmer is the proper utensil.

In earlier times, grease was poured into tubular "bottles" made of kelp and coiled for storage in wooden boxes. Boxes made by bending kerfed corners to form all four sides from a single plank were the common storage containers for the entire northern half of the coast. A box in the Newcombe collection (fig. 2), purchased at Gwai'i, illustrates the Kwakiutl type, with corner kerfs on both inside and outside of the bends, geometric patterning of shallow, parallel grooves, and a lid with upraised flange (Holm 1987, pp. 96–97). To reinforce the box and secure the lid, an ingenious network of native-made cord surrounds the box, joined at each crossing by a unique

knot. At the points of greatest potential wear, where the network passes over the upper and lower corners of the box, the cords are covered with a protective serving. A single line connects the upper loops and secures the box. In addition to their use as containers for everything from preserved food to ceremonial paraphernalia, boxes served a variety of purposes. Being watertight, they were used as cooking utensils. When filled with water that was heated to boiling with red-hot rocks, they served well for a people without pottery until the introduction of metal pots by traders. A special form of box was used as a drum and certain boxes were reserved as urinals. (Boas 1897, fig. 36, pl. 29; Holm 1987, no. 71). Ancient decorated lids were important features of noble marriages (Boas 1897, p. 421; Holm 1987, no. 33), and some boxes became coffins, deposited in caves or on the branches of tall spruce trees.

Woodwork, both utilitarian and artistic, requires appropriate tools. The principal woodworking tool on the Northwest Coast was the adze. The Kwakiutl midway along the Northwest Coast used both the northern elbow adze and the southern D adze (Boas 1909, pp. 320–321; Holm 1987, no. 19). Before the fur trade period the blades were of stone, but as soon as iron was readily available stone blades were discarded in favor of the superior material. Newcombe collected a typical Kwakiutl D adze, with steel blade and handle of crab apple wood, at Gwai'i (fig. 3).

Gwai'i, several miles up the Kingcome River beyond the head of 25-mile-long Kingcome Inlet, was

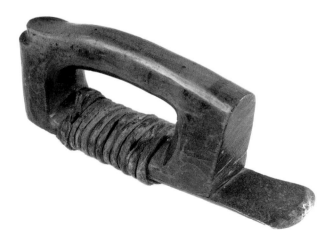

Fig. 3. Kwakiutl D Adze, 17-17-10/87074

a conservative village and one which had not been heavily visited by collectors, although none had been safe from the competitive scramble for artifacts. Much of the collection that Newcombe gathered for the Peabody Museum came from there. Everyday items of

Fig. 4. Cedar Bark Shredder, Kwakiutl, 17-17-10/87092

use, like the grease skimmer, box, and adze, became part of the group of objects that Newcombe and Nowell acquired. A ladle of hemlock wood with flaring bowl smoothly extending as a curved handle, angled at the tip in typical Kwakiutl form, was among them, as was a whalebone cedar bark shredder, polished and worn with use (fig. 4). This was an essential tool in earlier times, used to soften the dried inner bark of the red cedar for a myriad of uses— clothing, towels and napkins, baby bedding and diapers, and the dress and regalia of the Winter Ceremonial. By 1917 newly introduced materials had largely taken the place of all these except the last, so cedar bark shredders were still in use, although the material they produced was used in the manufacture and decoration of masks, neck and head rings, and other paraphernalia whose use was illegal under the terms of the Indian Act in Canada.

For over thirty years ceremonial activities associated with potlatching and the Winter Dance had been prohibited by provisions of the Act, and the Kwakiutl had borne the brunt of the sporadic efforts of the government to enforce the law. The potlatch was still openly practiced in the outlying villages, however, and Dr. Newcombe and Charles Nowell (an active participant) were able to acquire fine examples of ceremonial material. In lavish feasts that were an important part of noble display, great ladles carried the food from carved bowls of high prestige, emblems of the host family recalling the adventures of noble ancestors (Boas 1897, plates 20–21, 1909, plates 43–44; Mochon 1966, pp. 88–91). Often in sets of four and each sculpted to represent important mythical figures, the bowls were named in speeches,

required special protocol in their presentation, and were often part of the dowry of a chief's daughter. They were made in many sizes, some so huge they resembled canoes, and a few were fitted with wheels so the heavily laden, mammoth vessels could be readily rolled into the feast house. Others were smaller, intended to serve a few guests. Two carved grizzly bears flank a small feast bowl in the Peabody Museum, collected by Dr. Newcombe at Gwai'i (fig. 5). The image of a copper, the symbol of wealth and chiefly prestige, juts from the handle of a large ladle in the Newcombe collection (fig. 6). Other ladles bear the likeness of the Dzoonokwa, a fabled humanoid monster of awesome power.

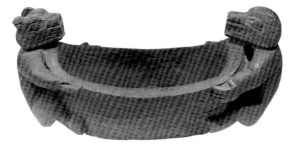

Fig. 5. Feast Bowl, Kwakiutl, 17-17-10/87176

The giving of feasts is a mark of nobility. Feasts are a tangible indication of the wealth and generosity of a noble man, and none could expect to retain respect for a chiefly name without lavish feastgiving. A complex protocol governed feasting—the inviting of guests, their order and placement of seating, the feast dishes that were set before them, and the appropriate foods. Among the inherited prerogatives of certain chiefs was the right to erect a carved figure on the roof of the house on the occasion of a feast to watch for the arrival of the guests (Boas 1897, fig. 25). Such a figure was collected by Newcombe at Memkwumlis, or Village Island, the village of the Mamalilikala tribe (p. i). The figure represents the host himself, or perhaps his speaker or representative, standing on the peak of the front gable, hands on belly, and staring intently forward toward the arriving guests. The carving, of red cedar, is in the typical Kwakiutl sculptural style of the period—bold and direct, with the planes of the face strongly incised. Similar figures were also stood up in the house at the time of feasts. Some of them were portraits of the host himself, represented in a favorable light as breaking a copper or otherwise

vanquishing his rivals, while others represented the rival as impoverished, cold, or subservient to the host (Boas 1897, p. 390, pls.18, 19; Holm 1983a, no. 196).

Associated with feasts and in many ways inseparable from them were the performances of the hereditary dance-dramas that were tangible evidence of the noble origins of the families. Bringing to life the deeds of heroic ancestors, their monster antagonists, and their supernaturally powerful benefactors was the goal of the performers and the carvers of masks. Most of these masks were highly stylized, with the bold planes and contrasting color schemes typical of the Kwakiutl, and were well calculated to utilize the dramatic shifting firelight of the ceremonial house. A Dzoonokwa mask, collected by Newcombe at Gwai'i, exemplifies the style (p. ii). Creature of terror and bestower of wealth, the

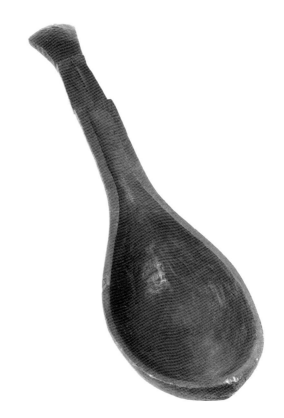

Fig. 6. Ladle, Kwakiutl, 17-17-10/87178

Dzoonokwa is one of a class of manlike monsters that, according to Indian tradition, inhabit the Northwest Coast (Boas 1897, pp. 372–374, 479, figs. 141–144; Hawthorn 1979, pp. 143–147; Holm 1983b, pp. 42–43; 1987, no. 38). It is considered to be yet with

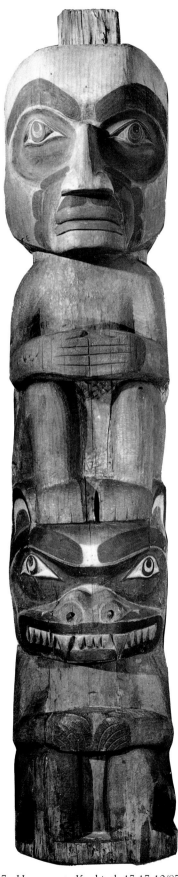

Fig. 7. House post, Kwakiutl, 17-17-10/87659

us by many Northwesterners, Indians and non-Indians alike. Of larger than human size, its bony face with heavy brow, arched nose, and protruding lip is calculated to strike terror in the beholder. Masks like the Peabody Museum's example were worn for that purpose, to remind the audience that a speaking chief commanded respect for his family and their prerogatives (Holm 1983b, pp. 157–159). The chief would hold the mask before his face and shout like the Dzoonokwa through its pursed lips. Typically the mask was painted black with graphite, producing a metallic sheen that contrasts with the vermillion-red accents of the lips, nostrils, ears, and recessed cheeks and temples. Lank locks of human hair crown the creature. It is a powerful image.

Another strange manlike being is represented in the Newcombe collection of Kwakiutl masks. Roughly and boldly carved, the mask features an immense nose, heavy, downslanted eyebrows, and a broad grin—all characteristic of the Noohlmahl, the Reckless Dancer (Boas 1897, pp. 468–471, figs. 113–123; Holm 1983b, p. 146; Mochon 1966, figs. 9–11). The Reckless Dancer (often called "Fool Dancer" in the literature) is the "enforcer" of the Winter Ceremonial, roughly treating transgressors of the rules of the ceremony and quick to lose self control and run wild. Dirty and aggressive, he sometimes intimidates with a tomahawk-like club or a spear and may throw mucus from his exaggerated nose onto the spectators (p. ii).

Not all masks are of violent or aggressive creatures. Newcombe collected a number of them that represent clan ancestors in the form in which they came to earth. One of them, with a near-human face and recurved, beak-like nose, represents Dzunhkai, the ancestor of the Dzundzunhkaio clan, who was a Kolus (a kind of thunderbird) before he became a man to found the clan (p. 127). Tufts of red-dyed cedar bark indicate that the mask was part of the Winter Ceremonial, for which the shredded red bark is the emblem. A mask such as this one might also be used in the mourning ceremony, when the spirit of the recently deceased chief returns in the form of his ancestral crest figure. After the spirit disappears, the attending chiefs return to the house with his mask, indicating that he has left his crests and legacy to his children. Dr. Newcombe collected this mask at the

village of Tsatsichnukwomi, or New Vancouver, on Harbledown Island.

Another mask (pp. 124–125) dramatizing a clan origin myth was also collected at Tsatsichnukwomi. It is an example of a transformation mask, a dramatic form at which the imaginative Kwakiutl sculptors excelled (Holm 1987, no. 42). It is a mask within a mask, the outer one of a raven splitting and folding outward in four parts to form the rays of the sun, represented by the inner face. The Kwakiutl name for this type of mask can be translated "folding out mask." It may dramatize a transformation such as that of a clan ancestor, often described in the myths as coming to earth as a bird or animal and removing his mask to become a man (Holm 1972, no. 45). Or, as seems likely in this case, it may combine representations of two different crest figures in one mask. The wearer generally enters the house from outside, opens the mask near the front door, and then proceeds slowly around the central fire to the back of the house. The attendants accompanying the dancer blow clouds of white eagle down over him.

One of the most striking figures of Kwakiutl mythology, and represented in what is probably the most spectacular mask in the collection (p. 3), is the Sisiutl, a fearsome multiheaded serpent (Boas 1897, pp. 370–372; Hawthorn 1979, pp. 124–127, fig. 341; Holm 1983b, pp. 57–59). The Sisiutl takes many forms, the most familiar being a creature with a large, central humanoid head surmounted by coiled horns and flanked by serpent-like extensions with similar horns and darting, red tongues. It is described as a very dangerous creature, the very sight of which can kill or convulse the viewer. But one with special knowledge could nullify the danger and acquire the power of the Sisiutl for his own gain. A large, boldly carved and painted mask, it probably appeared at the back of the firelit dance house over a screen that concealed the dancer's body. The lateral bodies extended back on either side of the central head. As the creature writhed, the serpent bodies swung out to extend to its full width (Curtis 1915, p. 213, pl. opp. p. 214; Mochon 1966, fig. 33). It was collected at Memkwumlis.

Of all the spectacular dance dramas of the Kwakiutl the most renowned is the return and taming of the Hamatsa or Man Eater. A dramatization of an

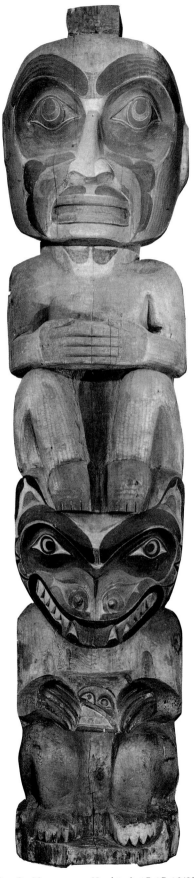

Fig. 8. House post, Kwakiutl, 17-17-10/87660

adventure of an ancestor, the new Hamatsa is apparently taken from his village by the Man-eating spirit, Bakhbakwalanooksiwey, and initiated into his ways. When finally the personified Bakhbakwalanooksiwey in the person of the new Hamatsa returns to his village, he is captured and subjected to a taming ritual of songs and dances. In the course of the ritual, dancers wearing great masks representing the bird-like associates of the Man Eater enter the house in a dramatic dance (Hawthorn 1979, pp. 105–113; Holm 1983b, pp. 85–120; 1987, no. 35). The masks are large and striking, painted black, white, and red, and set with twisted ropes, tufts, and hanging fringes of red-dyed cedar bark. Similar cedar-bark hangings cover the dancers' bodies. Two of the several distinctive man-eating birds are represented in the Peabody Museum's collection. One, with a long, bluntly pointed beak represents the Man-eating Raven, collected at Memkwumlis (p. vi). The other, from Gwai'i, with wide mouth and hooked snout is the Crooked Beak of the Sky (p. 126). The dancers enter the firelit house one by one at the repeat of the song, dancing upright and then crouching and hopping from side to side. At the end of each verse they sit on the floor, swinging and turning the great beaks. As they rise, their jaws loudly snap and clatter, and they move to the next corner to continue the dance. Wavering firelight reflected from the masks and casting deep shadows, sparks and smoke, the rise and fall of the song, and the pulsing beat of the singers' batons all combine to evoke the house of the Man Eater.

Charles Newcombe was, without doubt, history's most successful collector of monumental totem poles. Many of the poles in the great museums of Canada, the United States, and England were acquired by him. He even sent a Haida pole to Australia and an interior house post to Germany (Cole 1985, pp. 231–235). In 1917 Newcombe had hoped to furnish a large Haida pole to the Peabody Museum, but it was too big for the exhibit space. On the opening of a new section of the museum it became possible to display larger pieces, and in 1921 he was able to buy for the museum a pair of large Kwakiutl house posts (figs. 7, 8), the columns supporting the roof beams of a "big house" in the Tlawitsis village of Kalukwees on Turnour Island. These posts, very similar to one another in composition (men squatting on grizzly bears) but differing in detail, are impressive examples of Kwakiutl monumental sculpture. They were a fitting crown to Newcombe's collecting effort for the Peabody Museum. On short notice and in two short seasons, he filled the gap in the Northwest Coast collection to Dr. Willoughby's satisfaction and to our good fortune.

References Cited

Boas, F.
1897 "Social Organization and Secret Societies of the Kwakiutl Indians." *Annual Report of the U.S. National Museum for 1895.* Washington, D.C.
1909 *The Kwakiutl of Vancouver Island.* Memoir of the American Museum of Natural History, no. 8, pp. 301–522.
Cole, D.
1985 *Captured Heritage: The Scramble for Northwest Coast Artifacts.* Douglas and McIntyre, Vancouver.
Curtis, E. S.
1915 *The North American Indian,* vol. 10. Johnson Reprint Corporation, New York, 1970.
Hawthorn, A.
1979 *Kwakiutl Art.* University of Washington Press, Seattle.
Holm, B.
1972 *Crooked Beak of Heaven.* University of Washington Press, Seattle.
1983a *The Box of Daylight.* Seattle Art Museum and University of Washington Press, Seattle.
1983b *Smoky-Top: The Art and Times of Willie Seaweed.* University of Washington Press, Seattle.

Holm, B. (*continued*)
1987 *Spirit and Ancestor: A Century of Northwest Coast Indian Art at the Burke Museum.* University of Washington Press, Seattle.
Holm, B. and G. Quimby
1980 *Edward S. Curtis in the Land of the War Canoes: A Pioneer Cinematographer in the Pacific Northwest.* University of Washington Press, Seattle.
Macnair, P.
1971 "Descriptive Notes on the Kwakiutl Manufacture of Eulachon Oil." *SYESIS,* vol. 4, pp. 169–171, December.
Mochon, M.
1966 *Masks of the Northwest Coast.* Publications in Primitive Art, 2, Milwaukee Public Museum.
Newcombe, C. and Willoughby, C.
1917 Unpublished correspondence. Peabody Museum, Harvard University, Cambridge.
Rohner, R.
1969 *The Ethnography of Franz Boas.* University of Chicago Press, Chicago.

Museums and Repatriation of Objects in Their Collections

Wilcomb E. Washburn

Director, Office of American Studies

Smithsonian Institution

Perhaps the crisis over the demand for repatriation of Indian relics from America's museums may help to solve—inadvertently—one of the principal problems facing museums: the need to reexamine frequently their activities and redefine their purposes. Can the acquisition of collections continue indefinitely, or will museums run out of money, space, and ability to house and conserve all the desirable things that they might otherwise want to acquire? Does a museum's commitment to education require the expenditure of increasing sums of money for the preparation of new, and modernization of old, exhibits? In dealing with the question of repatriation of Indian goods currently held in a museum such as Harvard's Peabody Museum, it is important to recall that the university's museum serves scholarship, not the other way round. The Indian artifacts in the museum were collected, for the most part, by Harvard ethnologists and archaeologists as a by-product of their research interests. At the time when most of the collecting was done, photography was either nonexistent or slow and bulky, motion picture cameras were a thing of the future, painting and sketching difficult and expensive, scholarly aids such as xerography, FAX machines, holography, laser discs, etc., unimaginable. Collecting the physical object was often the only practicable way of studying it.

Archaeology and ethnology have gone through rapid changes in their techniques, assumptions, and interests. Gordon Willey and Jerry Sabloff (1974), Bruce Trigger (1978), Robert McC. Adams (1968), and scholars like Lewis R. Binford have recorded the radical changes in the perspective of American archaeologists. In ethnology, there has been a revolution in how "the Other" of North American Indian cultures is perceived, as well as how "the Self"—the ethnographer—should be conceived

(James Clifford 1988; Pat Caplan 1988). As a result of such changes in the discipline of anthropology, the research interests of those who use museums have changed. The museum, to the extent that it is a living organism, should reflect these changes.

Even if museums were not the servants but the masters of those who keep museums, change would be called for. Museums grew out of private *kunstkammer* and cabinets of curiosity during the period of the Renaissance. Pride of possession of the unusual and unique still motivates private collectors and, to some extent, public museums as well. The "era of pillaging," as Robert Adams put it, the competitive passion for "acquiring beautiful objects with a minimum of supervision or record keeping," as practiced by museums, is now at an end (1968, p. 1188). Museums have become more conscious of their ethical responsibilities to host countries in the acquisition of museum objects. Indeed, most archaeological expeditions in foreign countries no longer remove permanently (if at all) the objects recovered from their excavations. They remain in the host country. The results of the expedition are published for a world-wide audience, but the objects themselves remain in the country of origin. Can anyone say that the interests of all parties have not been met?

In the United States the revival of tribal governments, whose relationship with federal, state, and local governments has been defined by the executive, legislative, and judicial branches of the United States government as a "government-to-government" relationship, suggests that the relationships between museums and foreign governments should increasingly serve as a model for the relationship between museums and Indian tribes. On the other hand, while Indian political autonomy has grown in recent years, there has been an

increasing convergence of Indian and non-Indian cultural life. As the "Other" of Native American cultures blends into the "Self" of the ethnographic observer (native or non-native) in a shared cultural context, the practice of treating Indian objects, whether sacred or profane, in a manner different from objects associated with the majority culture ceases. Ultimately, Indian anthropologists and archaeologists (despite the claim of some Indians that there are no Indian archaeologists), working shoulder-to-shoulder with their non-Indian colleagues in America's museums and universities, will depoliticize and defuse the present apparent opposition between the interests of Indians and the interests of museums. When that time arrives in the United States (as it already has in much of Latin America), there will continue to be questions to resolve, but they will not be resolved as the outcome of a bitter fight between "them" and "us." Sometimes legal restraints will determine what can be exhibited or retained; sometimes moral considerations, sometimes considerations of "good taste." How the American flag is displayed in museums, for example, is subject to such considerations since it is not a simple piece of cloth to Americans—whether Indian or non-Indian—but loaded with symbolic, emotional, and legal content. In the current exhibition, the Consecration Board of the Oglala Teton Sioux (p. 96), used during the consecration ceremonies in the initial stages of the Sun Dance, may be analogized to the American flag. The label on the back of the board reads, "Inge & Mahone, Factory no. 17 Second District, Petersburg, Virginia." But it is, of course, much more than a piece of wood just as the flag is much more than a piece of cloth. The pipe used during the Sun Dance has similar sacred as well as material characteristics. The curators of the present exhibition have shown the same sensitivity in exhibiting and describing such objects as they would objects and ideas associated with the Jewish, Christian, Buddhist, or Islamic communities in the United States, taking into consideration the varieties of practices and beliefs that differentiate the major religions, as well as the attitude each faith, or sect within the same faith, takes toward the display of objects of special reverence.

If one accepts the notion that the purpose of an object in a museum is to support the study of some aspect of the culture in which that object is embedded, then it is of secondary importance whether that object is permanently "owned" by the museum. If the object has been fully described and studied using the techniques available today, the scholarly character of the object will have been "captured" for the scholar, whether or not the object is in his "possession," which it never is (in personal terms) even when it is in the possession of the museum in which he is working. True, all scholars and curators would like permanent and direct access (by touch and by sight) to original objects unchanged from their pristine appearance. But how realistic is it to expect to achieve this ideal? Objects are subject to the ravages of time and accidents inside museums as well as outside museums. Indeed, as I have pointed out in the case of the archaeological relics of the sixteenth-century English explorer Martin Frobisher, donated to the Smithsonian and the Royal Geographical Society with great fanfare by the Arctic explorer Captain Charles Francis Hall in 1861–1862, important objects are frequently lost or cast out by museums (Sayre, Washburn, Olin and Fitzhugh 1982). The loss of the correspondence and records of James Smithson, founder of the Smithsonian Institution, laboriously assembled in the nineteenth century only to go up in smoke in the fire in the Smithsonian Building in 1865, demonstrates that knowledge is sometimes as apt to be lost as gained by museum collection activities.

But what of the interests of "Science" and the disinterested pursuit of knowledge? Unfortunately that issue, particularly in the case of human skeletal remains, has been politicized and publicized to the point that it is probably not amenable to rational debate at the present time. As presented by the proponents of reburial, such as Vine Deloria, Jr. (1989), it is "a simple question of humanity." The issue and the opposing points of view have been well stated by Douglas H. Ubelaker and Lauryn Guttenplan Grant (1989). Because of the politicization of the repatriation issue as it affects Indian remains, it is probably a losing issue for museums to contest on a theoretical basis. But, because of the various legal restrictions on precipitate repatriation, and because opinion surveys have revealed that a surprisingly large percentage of Indians

support the notion of scientific excavation and study of human remains (though not necessarily of their exhibition or permanent retention as museum objects) (*ibid.* p. 255), such issues can be handled on a case-by-case basis, quietly, with minimum loss to science. As Indian cultures and the majority culture increasingly overlap, it is entirely conceivable that the interests of both Indians and science can be satisfied. In most cases objects, including skeletal remains, are being returned to Indian control but not "lost" forever, particularly in the case of nonskeletal objects, which are normally consigned to local Indian museums. These museums will now have a chance to show whether they can conserve the history of their tribe's past as well as or better than non-Indian museums have done.

As the debate shifts from the simple emotional character in which it is presently mired to a more sophisticated level, museums can put difficult questions to the more radical proponents of repatriation. When Native Americans, such as the inhabitants of St. Lawrence island in Alaska, unceremoniously disturb their ancestors' graveyards to extract grave goods for unregulated sale to casual buyers (Crowell 1984), museums legitimately can ask whether an ethnic group has not a sacred obligation to the human family, of which it is a part, to preserve its cultural heritage.

One can ask whether the long-term retention of an object is as necessary for the educational function of the museum as for its research function. The education of others might be enhanced rather than diminished by transferring an object to an institution in the culture area from which it was recovered after its research potential has been appropriately recorded. In this day of rapid and easy transportation, centralized depositories do not play the same role they once did. The pleasure of others in receiving what one gives should also be counted as a value received, particularly when it can be interpreted as a retroactive expression of thanks for earlier cooperation, whether knowing or unknowing. The cost in dollars saved from not having to store, care for, or exhibit an object indefinitely can be applied to the discovery and analysis of another object. All museums today are faced with a need for additional space to house new collections. I attempted to

quantify the cost of exhibition and storage space in my article "Collecting Information, Not Objects" (Washburn 1984). Costs of either storage or exhibition are so high that no museum (except possibly national "museums of record") can contemplate with equanimity the constant expansion of its collections.

This is not to say that collecting should cease. Rather, it must become increasingly discriminating and increasingly related to research needs currently underway or contemplated. No museum can continue to engage in "indiscriminate acquisitions of collections," as one contemporary museum director has noted. Joseph Henry, first secretary of the Smithsonian Institution, issued a warning that all museum directors should take to heart when he wrote that "there is indeed no plan by which the funds of an Institution may be more inefficiently expended, than that of filling a costly building with an indiscriminate collection of objects of curiosity, and giving these in charge to a set of inactive curators" (*Annual Report for 1850*, quoted in Washburn 1967).

In sum, repatriation of objects from existing museum collections can be looked upon as a gain or a loss depending upon how the purpose of the museum is facilitated or harmed by such repatriation. Since the advance of knowledge does not necessarily require the retention of the objects utilized for that advance, museums should frequently reassess their priorities (and budgets) with regard to collections, education, and research.

References Cited

Adam, R. McC.
 1968 "Archaeological Research Strategies: Past and Present," *Science*, vol. 160, no. 3833, pp. 1187–1192.
Caplan, P.
 1988 "Engendering Knowledge: The Politics of Ethnography," *Anthropology Today*, vol. 4, no. 5, pp. 8–12.
Clifford, J.
 1988 *The Predicament of Culture: Twentieth-Century Ethnography, Literature, and Art.* Harvard University Press, Cambridge.
Crowell, A. L.
 1984 Cited in W. E. Washburn, "Increasing Our Knowledge of Pre-Columbian Civilizations by Not Collecting Pre-Columbian Objects," in *Pre-Columbian Collections in European Museums*, A. M. Hocquenghem, P. Tamasi, and C. Villain-Gandossi (eds.), pp. 28–33. Akademiai Kiado, Budapest. (1987)
Deloria, Jr., V.
 1989 "A Simple Question of Humanity: The Moral Dimensions of the Reburial Issue," *Native American Rights Fund Legal Review*, vol. 14, no. 4, pp. 1–12.

Sayre, E. V., W. E. Washburn, J. S. Olin, and W. Fitzhugh.
 1982 "The Carbon-14 Dating of an Iron Bloom Associated with the
 Voyages of Sir Martin Frobisher," in *Nuclear and Chemical
 Dating Techniques: Interpreting the Environmental Record,* L. A.
 Currie (ed.), pp. 441–451. American Chemical Society,
 Washington, D.C.
Trigger, B.
 1978 *Time and Traditions: Essays in Archaeological Interpretation.*
 New York.
Ubelaker, D. H., and L. G. Grant.
 1989 "Human Skeletal Remains: Preservation or Reburial?," in
 Yearbook of Physical Anthropology 32:249–287.

Washburn, W. E.
 1967 "Joseph Henry's Conception of the Purpose of the Smithsonian
 Institution," in *A Cabinet of Curiosities: Five Episodes in the
 Evolution of American Museums,* W. M. Whitehill (ed.), pp.
 106–166. University Press of Virginia, Charlottesville.
 1984 "Collecting Information, Not Objects," in *Museum News,* vol.
 62, no. 3, pp. 5–15.
Willey, G. R. and J. Sabloff.
 1974 *A History of American Archaeology.* Thames and Hudson,
 London.

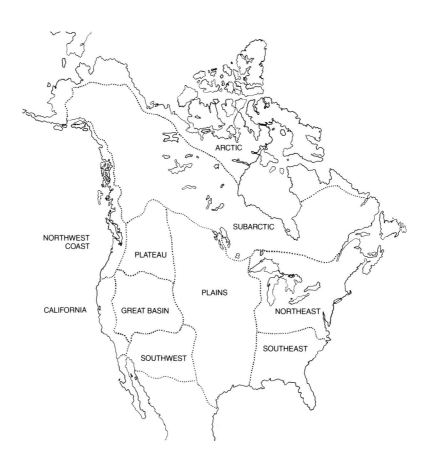

North American culture areas as treated
in the Hall of the North American Indian.

Changing Perceptions of North American Indian Art

J.J. Brody

Professor Emeritus, Department of Art and Art History
University of New Mexico

The North American Indian and Eskimo objects of art included in this catalogue were selected from among more than five hundred artifacts which appear in an exhibition that interprets the lifeways of Native American people. As an anthropology exhibition in an anthropology museum, the story it tells is of change and continuity in North American Indian life during the hundreds of years of interaction between the Native Americans and the Europeans. Appropriately enough, its primary concern is with sociocultural issues that happen to be set within frameworks of geography and political and social history. The objects in it were selected from among many thousands of possibilities to illustrate and symbolize different aspects of the major exhibition themes.

The objects are all handmade things that were once useful—tools, clothing, ornaments, and other artifacts used in daily work and play—and things of ideological utility with special social, ritual, or political significance. As well as being useful, most were made with skill, formed with elegance, and decorated with attractive abstract or realistic patterns and images that can provoke emotional involvement. They were often created by the very people who made use of them, and as their formal attributes are generally distinctive of particular small social groups at a certain time in the history of Native Americans, they also communicate social identity. We can rarely identify individual craftsmen, but we can usually tell by looking at an object to what group its maker belonged, and where and when the thing was made. Within the exhibition many of the artifacts are set in contexts that acknowledge that message of identity, that are appropriate to their original use, and are suggestive of their original functions.

As is true of most objects in most museums, it is not likely that any of these were made for their present interpretive purposes, but they continue to be utilitarian, only now it is as elements of a museum exhibition. In this, they serve the logic and rationality of a novel and alien medium. They become, however briefly, the elements of a large-scale environmental construction—the exhibition—and they are the equivalent of sounds, colors, forms, lines, spaces, textures, and intervals that are the fundamental units of a single work of art in any other medium. The formal goal of this exhibition is also shared with works of art, for it aims at the creative ideal of a unity within which no element can be added and none subtracted without destroying internal harmony. As with any work of art, the elements, the artifacts, may be put into new configurations at any time and restructured according to different logics. They will then make a different kind of sense and perhaps serve some other, entirely independent purpose. Often, as in this essay, artifacts are reconfigured as works of art within the structure of art history (Kubler 1962; Maquet 1971).

As the shift is made from anthropology to art history, perceptions of the artifacts change. The artifacts seem to grow in size, relative scale, and importance, for a work of art must be intensely visible, isolated so that it can be examined and contemplated as though it were unique (Maquet 1986, pp. 35–58). The important thing about this transformation is that the tangible, physical properties of the object do not change at all. The alteration is mental and has to do with perception, classification, the tools of examination, and, ultimately, ideology.

Thus, the meanings and values given to transformed objects change, for art is not the same thing as artifact. There are no correct or incorrect

modes of analysis here, no right or wrong, no lies, just different truths, each a function of the scale and scope of examination. Anthropology concerns all aspects of human behavior, art history relatively few. The one looks at artifacts as types of objects within classes and as units of a very large whole, the other sees them as unique, individually made things, each different from all others of its class. To some degree all art objects may reasonably be perceived as artifacts, and all artifacts as art objects (Anderson 1979, pp. 8–14, 187–201). In practice, though this is not always acknowledged, each discipline not only recognizes the perceptive validity of the other, but it frequently shares and draws insights from those perceptions (Hatcher 1985: 197–207; Kubler 1962). Also, even though they must often be reminded, both disciplines know that the original makers and users of the objects probably had something else in mind and perceived them from yet other points of view. The two disciplines support each other, and so long as they periodically refer back to the tangible reality of the objects, the perceptions that each have of them will also overlap and intersect with those of the original makers and users.

Once made, objects can behave like organisms for they are given a pseudo-life by all future users that is independent of their origins. They are bundles of physical properties that, so long as memories of them exist, will be available for interpretation and have the potential to exert influence (Kubler 1962, pp. 83–122). Their tangibility is transcendent and independent of any perceptions that any people may have of them or any meanings that any people may give to them. All of the meanings and perceptions are user-specific: they may become a part of the history of an object but never a part of its fabric. The history of the making of an object is only the beginning of its history.

Artifact and Art

Art or artifact, all made things are individual units of a sequence, series, class, and type; they are aspects of history (Kubler 1962, pp. 31–39). The unique tangible qualities that give made things definition—the materials, forms, shapes, colors, textures, and the relationships among these—are not only constrained by particular times, spaces, and experiences, but they become abstract representations of those intangible realities. When we perceive

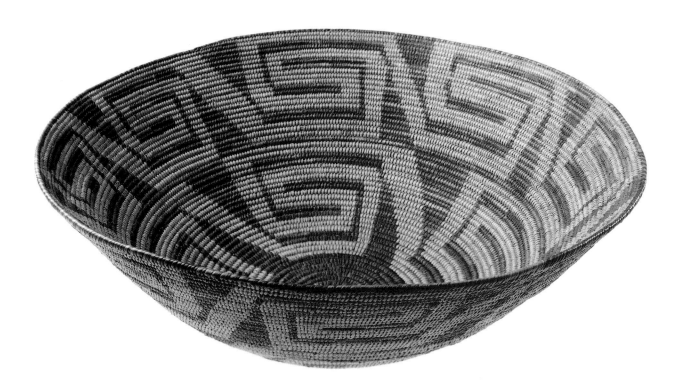

Fig. 9. Basket, Pima, 65-10-10/44002

individual abstract qualities to be dominant and judge the object to be a meaningful abstract form rather than a useful tool or an incomprehensible image, we have transformed it into art. We can then focus upon either of two entirely separate art historical issues: the history of the making of the object, or the history of its later uses and transformations. In either case, the perception that an abstract form is meaningful together with any meanings or values that may be attached to it are facts independent of the fact of the form itself.

All people are trained to perceive, classify, and evaluate formal relationships, and the judgments they make about them are colored by the history of their training. The old and persistent question How do we distinguish between (fine) art and artifact? is meaningless unless placed within the framework of a particular history, for it refers not to the object, but rather to how it is classified. The answer will always be contingent upon historical context. It seems that no American Indian people had a class of object that they called "fine art," therefore the question Art or artifact? could have had no meaning in the context of the traditions that produced these objects. It can only be examined in the context of classification systems, such as the Euroamerican, that have a "fine art" category.

Under the rules of the post-Renaissance, premodern Euroamerican art classification system in effect when most of the art-artifacts here were collected, artistic categories were hierarchical, ranging from high-status "fine art" to low-status "decorative (or applied) art." The category of fine art was reserved for two classes of objects that were made to be looked at: painting and, somewhat lower in status, sculpture (Maquet 1986, pp. 13–50). Formal illusionism and subject matter that supported the values of the art patrons were critical to fine art status. Paintings were required to give an illusion of three-dimensional reality on a two-dimensional plane surface, and sculptures, truly three-dimensional, were also supposed to mimic real-world appearances except that they could not be artificially or illusionistically colored. There were other hierarchies, especially having to do with subject matter, and minor rules, as in any dynamic system, were in a constant state of flux.

No useful object, no artifact, would be classed as fine art, nor could any subject that was unacceptable to the political, economic, and religious interests of the art patrons. Objects of decorative art could approach high status only by being less rather than more useful, by being made of inappropriate or precious materials, or by inefficiency of form. If useful and efficient Euroamerican artifacts of common materials could not be classified as fine art, and might not even be considered decorative art, it was hardly likely that artifacts of similar quality from societies conquered, colonized, or thought to be inferior could be so classified. Nor could objects from those societies be classified as fine art if their form or subject matter were perceived as incomprehensible, or subversive of Euroamerican religious or social values. The highest status they could achieve was that of "artificial curiosity" (Feest 1980, pp. 9–19).

As the industrial revolution took hold in the nineteenth century, some efficiently designed, handmade, utilitarian objects made for an emerging, upwardly mobile middle class by artists associated with various arts-and-crafts movements were given higher status. This opened possibilities for reclassifying other artifacts. About the same time, avant-garde modernism radically altered the formal attributes and the subject matter of the fine arts (Goldwater 1967; Rubin 1984). A paradigmatic shift occurred early in the twentieth century when Cubist artists placed real-world, three-dimensional objects in their nonillusionistic paintings and artificial colors and abstract textures on the surfaces of planar, nonillusionistic sculptures. In either case, subject matter was either neutral or antiestablishment. The abandonment of illusionism, the use of neutral or subversive subject matter, and the fusion of painting and sculpture made the old fine art classification system obsolete. It was now possible to consider any form of object, including artifacts, and any kind of subject, including the incomprehensible, as fine art.

The influence of Cubism and other modernist fine arts upon the Euroamerican art classification system was profound, and that of the many arts and crafts movements, pervasive. Between them they made possible what had been impossible a century ago, the transformation of many kinds of artifacts into art. Public art museums are the modern institutions

that function to test and validate the art classification systems of an increasingly complex, international, urban-industrial society. Except for the Denver Art Museum, which began to collect American Indian art in 1925, art museum acquisitions and exhibitions of North American Indian objects lagged behind their interest in equally exotic objects from Africa and Oceania. The first comprehensive American Indian art exhibition organized by a major urban American art museum was at the Museum of Modern Art in New York in 1941. Frederic Douglas of the Denver Art Museum and René d'Harnoncourt of the Museum of Modern Art were the organizers, and the book they wrote for the exhibition was the first art history of Indian art. After a half century, it remains among the best (Douglas and d'Harnoncourt 1941).

The Museum of Modern Art was an appropriate venue. Little more than a decade old, it had been extraordinarily successful in teaching about and promoting the modernist art revolution in the United States. Its Indian art exhibition followed exhibits there of African, Oceanic, and

pre-Columbian art, which, collectively, were a clear statement by an authoritative art museum of the change in the art classification system. Neither evident utility of artifacts nor incomprehensibility of subject matter were barriers any longer to reclassifying objects of exotic traditions as art within the Euroamerican system. Even so, more than three generations after the Cubist revolution, many art schools and art museums still conform to the old rules that paintings and sculpture are separate fine arts, and that useful objects of any cultural tradition cannot be objects of fine art. It is true that many of these institutions now include artifacts and other objects in their collections taken from alien traditions that they have transformed into art. But, with rare exception, those objects are kept in departments separate from both fine arts and Euroamerican decorative arts; no longer "artificial curiosities," they are instead a new class of art object with no agreed-upon name.

That the full transformation to fine art status of objects produced by alien societies occurs so seldom suggests that knowledge of the social and historical

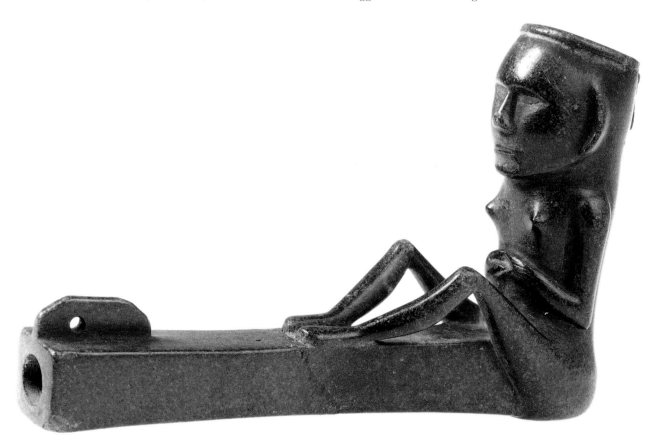

Fig. 10. Human Effigy Pipe, Cherokee, 90-21-10/51060

contexts that structure all art is categorically more important than was once thought. Contemplation, recognition of significant form, and appreciation of abstract qualities tell us little about intellectual processes and the humanity that is made tangible by objects. The form and content of objects are products of individual human decisions patterned by history, and exotic objects whose histories are unknown in their new contexts are especially vulnerable to being dehumanized. Isolation may be needed in order to focus on form, and ignorance of meaning from lack of context is no barrier to recognition of abstractions; but forms are made by social beings, and abstractions are wordless messages sent by one individual to countless others. Incomprehension matters, and the social history of objects must be known for them to be decoded and placed in an appropriate category. One approach to the comprehension of art is through art history informed by anthropology, and for American Indian art, the road to fine art may lead through an anthropology museum.

Geography, History, and American Indian Art

The use by anthropologists of geography and history as frameworks within which to organize artifacts for interpreting Native American lifeways very nicely parallels an art-historical approach to those very same objects. Those frameworks superimpose patterns of diversity and variety onto the notion that there may have been a uniform "American Indian" way of making objects. The premise then develops that adaptations to the totality of the geographical, natural, and human environments within which people found themselves are of fundamental importance to the histories of the various Indian peoples, their distinctive lifeways, and their arts. The formal qualities of art and artifact made by the different Native American peoples are either more or less alike, depending on where they are (or were) in the vast mosaic of the North American continent rather than on who they are as individuals or who their ancestors were.

The geography of the New World and the geopolitical facts of the Old patterned the noteworthy incidents and events that we focus upon as "history" as well as the more prosaic contacts between Indians and Europeans that were far more commonplace.

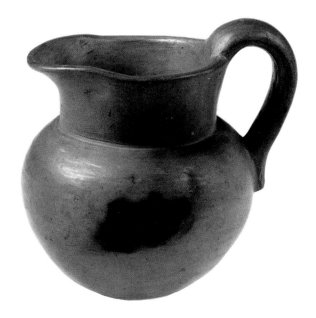

Fig. 11. Pot, Cherokee, 47-66-10/29394

Thus, the impacts of both ordinary and extraordinary historical contacts upon different Native American peoples varied greatly from place to place and time to time. Not surprisingly, modifications in the form, content, and material of Indian artifacts and art varied also in response to the same historical events. Those frameworks of geography and history are more than simple organizational procedures, they establish the logical structures within which orderly, consistent analyses of phenomena can take place. Unlike the problem of art and artifact which can be made useful by context, the old query What is Indian about Indian art? is simply vaporized when geography and history shift the focus to smaller, well-defined arenas where the answer is so obvious that the question has no meaning.

Geographical and historical frameworks have long been used as organizational devices for the study of Indian art. Douglas and d'Harnoncourt (1941) structured their landmark exhibition and history of Indian art along geographic lines, which they called "art areas," and only a few useful alternative structures have been offered since then. The one that treats all of native North America as though it were a single art-historical entity can be helpful in some kinds of comparative studies (Feest 1980). However, in the most extreme applications of this structuring, the marvelous diversity of these arts and the unique qualities of individual peoples are smothered under

the uniform umbrella of a deceptive and indescribable "Indian-ness." At the opposite pole, each of the thousands of Native American art traditions can be viewed as a unique event. This framework is necessary for fine-grained studies that provide the factual bases for the broader, more generalized works, and is an essential approach if we are to comprehend an otherwise chaotic Native American art universe.

The geographical and historical frameworks with their necessary emphasis upon regional traditions should not disguise the fact that certain common themes seem to run through all of Native American art, at least until very recent times. Virtually all of these, such as gender specialization in art production and art use, the fusing of art and artifact, the almost universal application of art to every kind and class of object, the many ways that art serves as a kind of integrative social "glue," and the assumption that art is to be used and discarded, are held in common by people of small-scale societies in all parts of the world (Anderson 1979; Hatcher 1985). While the many variants of these themes—as for example whether weaving in a particular tradition is done by men or by women—are subject to historical explanation, the broad themes themselves seem to be beyond the scope of either history or geography. More general social or behavioral theoretical frameworks such as may be provided by the discipline of anthropology are needed. There may be other art themes unique to North America that are shared by all or most Native American people, but if so, they must be very few indeed for they seem not to have been isolated and described.

Distinctive art traditions occurring in several geographic regions are (or were) found until recently only in those areas. These art regions roughly parallel the geographical divisions that structure the exhibition from which these art-artifacts were selected. They are a variation of the culture area framework articulated by the American anthropologist A. L. Kroeber in 1939 but were used long before then by Kroeber and many others in museums and other teaching contexts. The boundaries of culture areas change through time, sometimes radically, and those of art areas change as well; here, we focus upon the late nineteenth and early twentieth centuries. Since art has been made in North America for at least

12,000 years, the art history of any art region can become exceedingly complex.

The nineteenth- and twentieth-century art traditions of some areas—for example, the Arctic and Northwest Coast—may be defined with relative ease even though close examination exposes many "small" temporal, social, and subregional traditions. The

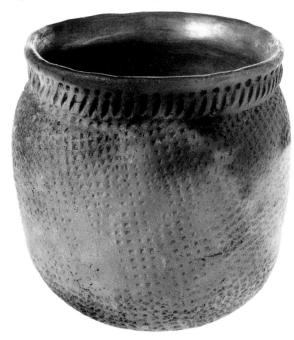

Fig. 12. Check-stamped Beaker, Cherokee, 08-17-10/73416

Arctic is perhaps the most stable of the art regions in terms of both form and content. For 2,500 years small, compact, volumetric carvings in bone, ivory, and wood characterized men's art of that vast area (Wardwell 1986) (p. 108). Much of it is on tools and religious objects associated with hunting or shamanism; some of it is quite realistic, and it often exhibits a strong element of fantasy (pp. 110, 104). The fantastic elements are often visual metaphors illustrating narrative events and environments (Ray 1967).

Materials not likely to survive for long characterize the best known arts of California, such as basketry and featherwork (pp. 78, 86). For that reason there is slim evidence of great antiquity with only the poorly dated media of rock art and stonecarvings known to be very old. Much men's art is ephemeral and associated with ritual and dance (pp. 82–86), while a great variety of baskets with small-scale and complex patterns were made by

women whose skills were a measure of personal quality and social stature (O'Neale 1932). The known art history of the Southwest is much more complicated, in part because so much art has survived for so long, and in part because archaeology has exposed so coherent a prehistory of the region (Ortiz 1979). Unbroken sequences of pottery art extend back more than 1,500 years (p. 56), and textile and basketry traditions are even older (fig. 9; p. 54). Art associated with Pueblo Katcina societies has been made for 600 years, and despite many modern changes in form, it still has powerful social and ritual meaning (pp. 53, 66). In contrast, the rich and very beautiful Navajo and Apache basketry traditions and Navajo weaving, despite complex histories, are only about 200 years old and as though born yesterday (p. 59). Much of the art made by all peoples throughout the region seems to express social harmony and balance and is, in some sense, a metaphor of prayer.

On the Plains, women's rationally organized, geometrically patterned paintings, quillwork, and beadwork, often placed on graceful and kinetic skin clothing were measures of personal virtue and social position (Bol 1989) (pp. 93, 99). Men's art was often an emotionally charged representation of a personal mystical or heroic experience (p. 94) or was for religious ritual (p. 97). The interactions of history and geography are dramatically illustrated by Plains art which by the eighteenth century was as distinctive and rich as that of the Northwest Coast, but prior to then had been an impoverished subregion of the Woodlands. The Woodlands art area includes Southern Canada and the United States east of the Mississippi River. Its art history is at least 5,000 years old and is comprehensible only by subdividing it in different ways during different time periods (Brose, Brown, and Penney 1985).

Some themes in Woodland art are both ancient and incredibly persistent. Plaited baskets with sinuous, interlocking patterns (p. 50), wood, stone, and ceramic effigy bowls and tobacco pipes with smoothly contoured forms and sensuous concern for raw materials (fig. 10; p. 28), and simple but elegant wide-mouthed, round-bottomed ceramic containers with textured surfaces (figs. 11, 12, 13) have all been made for thousands of years by different peoples throughout the region. Abstract geometric patterns

that are bilaterally symmetrical across several axes (p. 51), curvilinear floral forms (p. 32), and balanced figure-ground relationships that create ambiguous positive-negative patterns (p. 47), all characterize the decorative arts of the region from time immemorial. And as elsewhere throughout North America, introduced materials and techniques and even novel forms were all absorbed into the fabric of ancient Native American art systems. Where ancient histories are best known, such as the Southwest, it is clear that Native American art had always been the diverse and dynamic product of diverse and dynamic peoples. Changing, absorbing, and modifying in the face of a myriad of known and unknown historical factors, Indian art, even at its most abstract, decorative, and utilitarian, was a concrete response to a unique human experience.

References Cited

Anderson, R. L.
 1979 *Art in Small-Scale Societies.* 2nd ed. Prentice Hall, Englewood Cliffs, N.J.
Bol, M.
 1989 *Gender in Art: A Comparison of Lakota Women's and Men's Art 1820–1920.* Unpublished Dissertation, University of New Mexico, Albuquerque.
Brose, D. S., J. A. Brown, and D. W. Penney
 1985 *Ancient Art of the American Woodland Indian.* Harry N. Abrams, Inc., New York.
Douglas, F. H., and R. d'Harnoncourt
 1941 *Indian Art of the United States.* The Museum of Modern Art, New York.
Feest, C. F.
 1980 *Native Arts of North America.* Oxford University Press, New York and Oxford.
Goldwater, R.
 1967 *Primitivism in Modern Art.* Vintage Books, New York.
Hatcher, E. P.
 1985 *Art as Culture.* University Press of America, Lanham, Md.
Kroeber, A. L.
 1939 *Cultural and Natural Areas of Native North America.* University of California Publications in American Archaeology and Ethnology. 38. Berkeley.
Kubler, G.
 1962 *The Shape of Time.* Yale University Press, New Haven.
Maquet, J.
 1971 *Introduction to Aesthetic Anthropology.* Addison-Wesley, Reading, Mass.
 1986 *The Aesthetic Experience.* Yale University Press, New Haven.

Ortiz, A., ed.
 1979 *Handbook of North American Indians, Southwest.* Smithsonian
 Institution, Washington, D.C.
O'Neale, L. M.
 1932 *Yurok-Karok Basket Weavers,* University of California
 Publications in American Archaeology and Ethnology, 32.
Ray, D. J.
 1967 *Eskimo Masks: Art and Ceremony.* University of Washington
 Press, Seattle.

Rubin, W., ed.
 1984 *"Primitivism" in Twentieth Century Art.* 2 vols. The Museum of
 Modern Art, New York.
Wardwell, A.
 1986 *Ancient Eskimo Ivories of the Bering Strait.* Hudson Hills Press,
 New York.

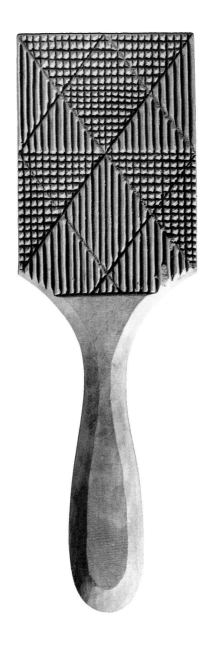

Fig. 13. Pottery Paddle, Cherokee, 08-17-10/73420

Northeast and Eastern Subarctic

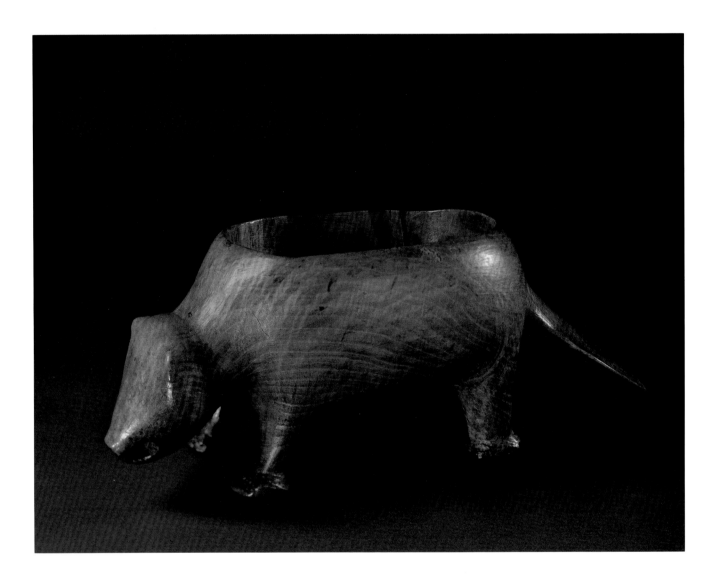

Beaver Bowl (Central Algonkian, possibly Kaskaskia)

99-12-10/52998 Length 40.5 cm.

This masterpiece, an ash root bowl carved in the shape of a beaver, indicates that the tradition of wood sculpture in the Northeast prior to the nineteenth century was a strong one. The bowl was collected by George Turner, Judge of the Western Territory, at the signing of the Greenville Treaty (1795), the first of many "final peace treaties" between the United States government and the various tribes of the Illinois Confederacy. Turner gave it to the Peale Museum in Philadelphia and it eventually came to the Peabody Museum in 1899. T1231

Sash (Iroquoian)

17-7-10/86863 Length 344 cm.

An important part of the Northeast Indian male's outfit was the sash. Items such as this finger woven sash were also commonly worn by French voyageurs and Metis (mixed bloods). T1227 (R)

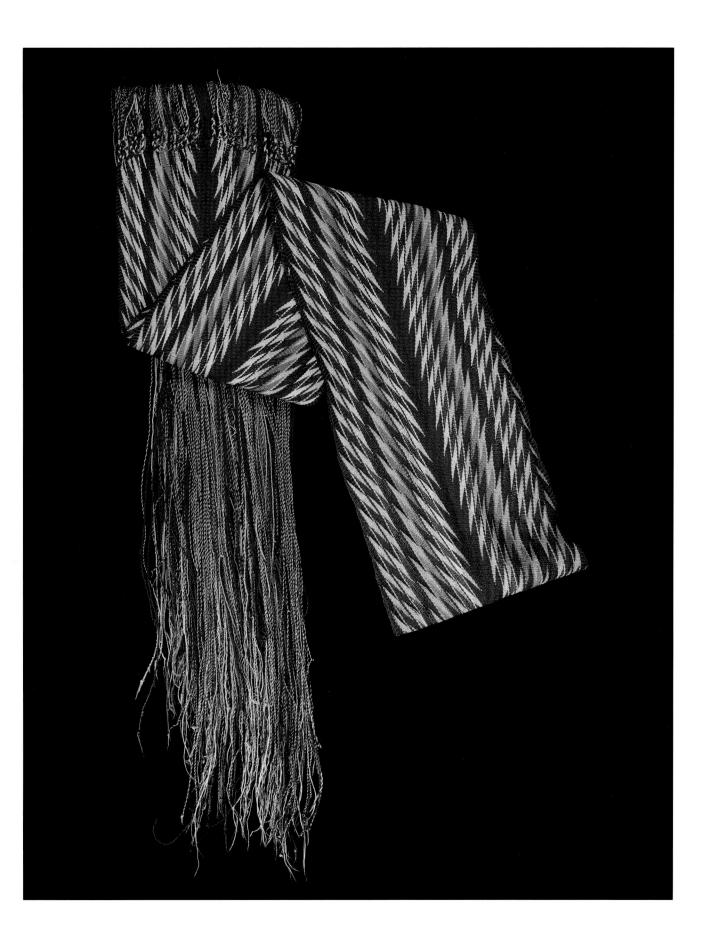

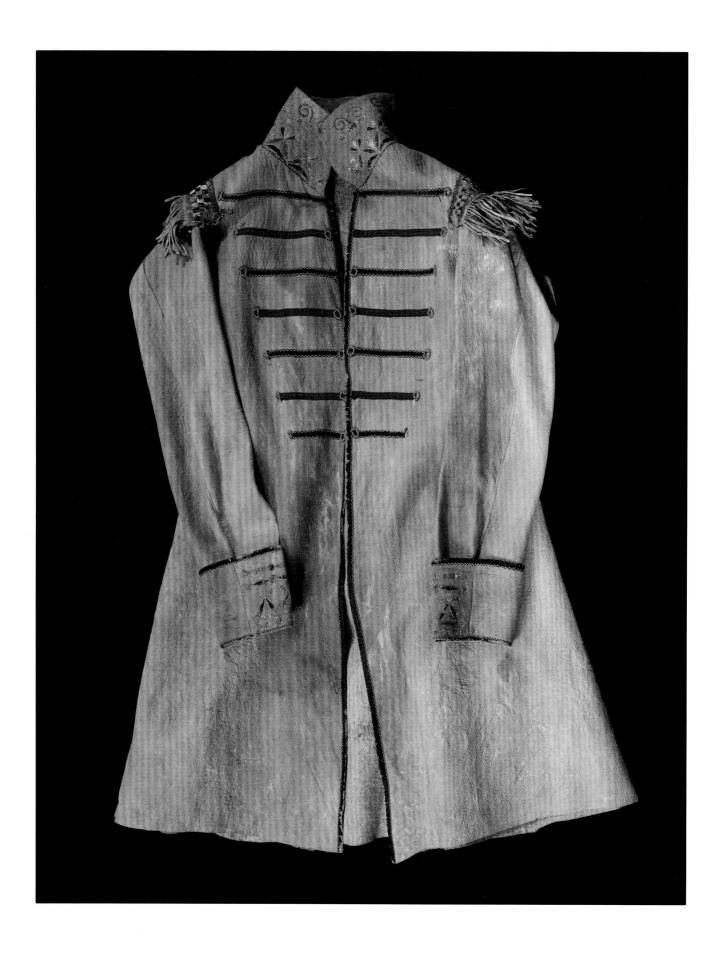

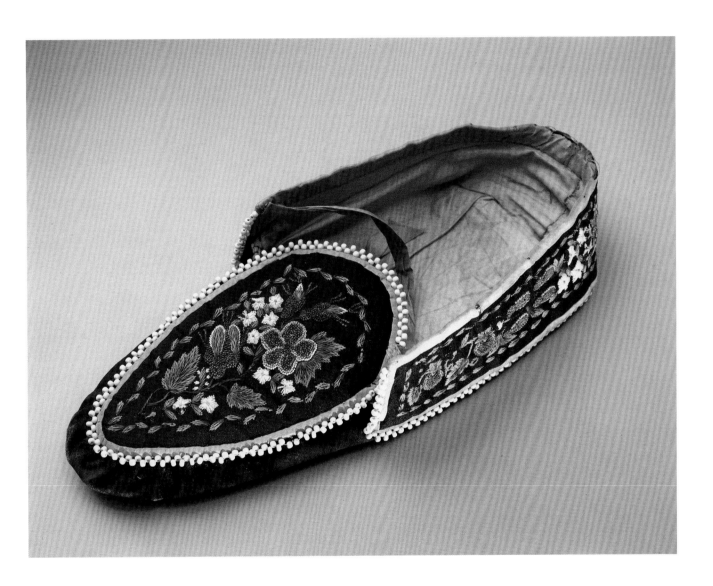

European Style Coat (Iroquoian/Huron?)

(05-9-10/64510) Length 113 cm.

This coat typifies the appeal that military outfits had to many Northeast Indians. The style of the coat is reminiscent of the 1780s, although the collar appears to be of early nineteenth century date. The coat itself was collected in 1839. T858 (L)

Moccasin (Huron)

40-39-10/19328 Length 25 cm.

Dyed moosehair embroidery in a fine, realistic flower pattern adorns this Huron moccasin. It was collected sometime between 1872 and 1902. T1287

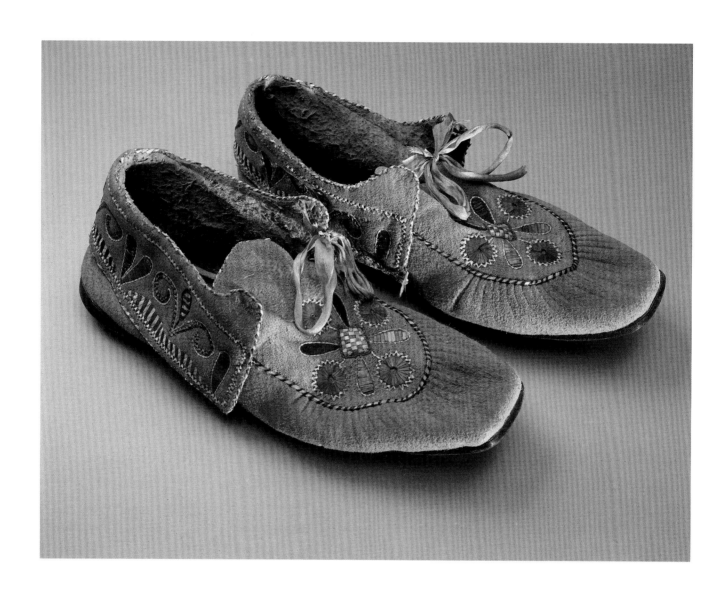

Moccasins (Iroquoian/Huron?)

27-15-10/98245 Length 22.5 cm.

A heavy, cowhide leather sole was combined with a smoked tanned, deerskin upper. The decoration is indigenous, with the edging of the vamp made out of white bird quills and purple porcupine quills. Silk ribbon ties are a delicate touch. Although these moccasins were supposed to have been collected by Capt. William Phelps in 1841, the purple color is an aniline dye which post-dates 1865. T1286 (Detail right)

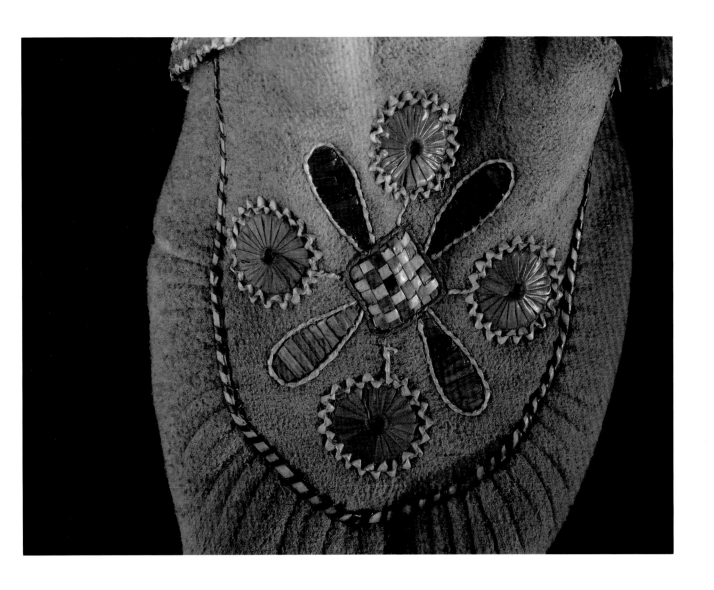

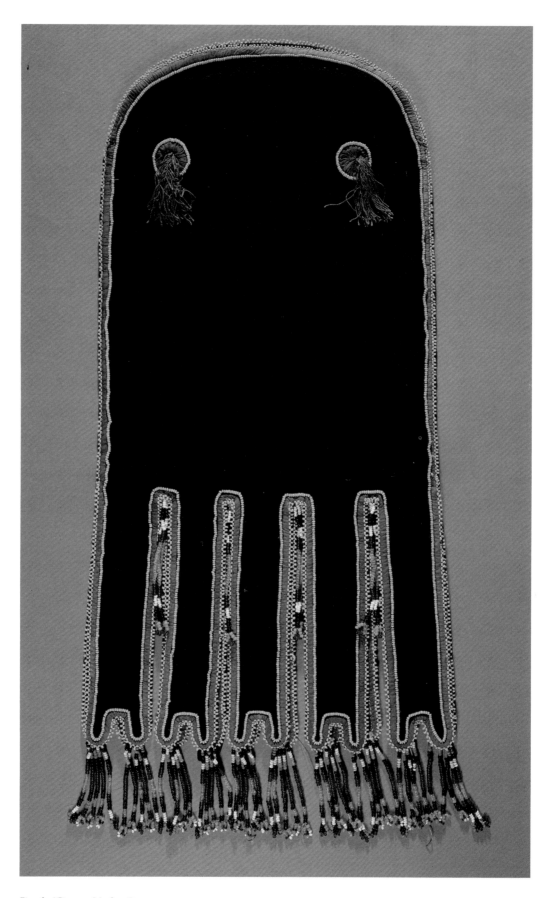

Pouch (Cree or Naskapi)

94-38-10/62488 Length 55 cm.

Pouches of this style are often referred to as "octopus bags" because they have eight tabs. They were popular in the nineteenth century in parts of the Subarctic, Plains and Northwest Coast. This pouch was collected in 1892. T1284

34

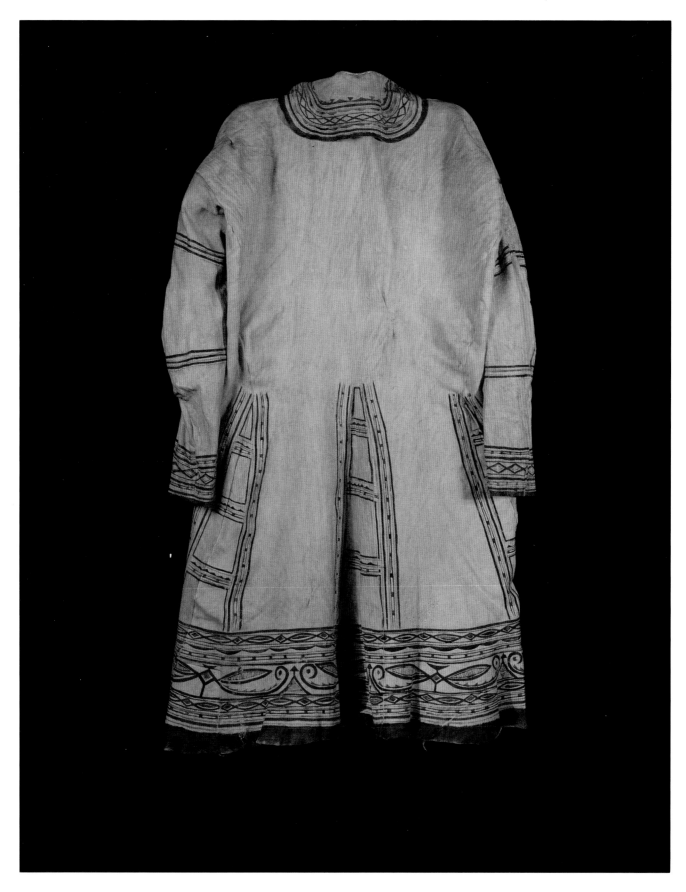

Caribou Hide Coat (Naskapi)

11-64-10/84099 Length 116.2 cm.

Naskapi coats usually bear complex geometric designs of a repeating double-curve element sandwiched between layers of parallel
serrated designs. This particular coat, which is unusually large, dates to the 1880s. Since it lacks a fur lining, it was clearly intended 35
for summer use. T1290

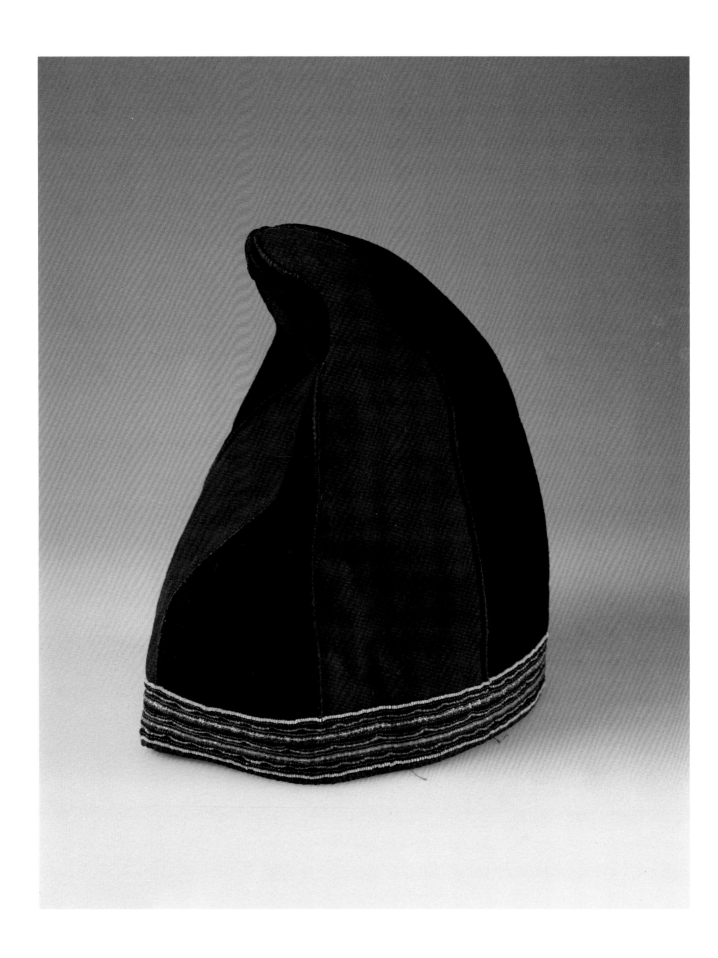

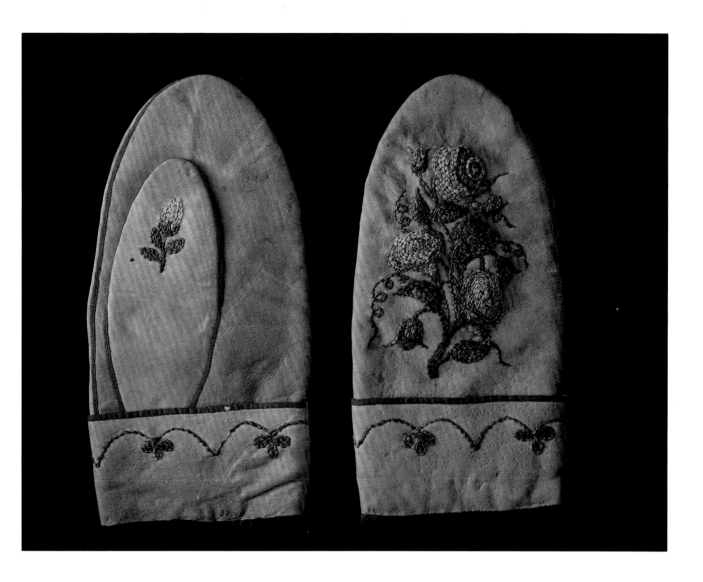

Hat (Naskapi)

49-30-10/32223 Height 28 cm.

Both men and women wore hats of either red, dark blue, light
blue, or black wool cloth, introduced by Hudson's Bay Company
traders. Sometimes five or six pieces were cut from different colors
of cloth. If the hat was to be of one color, however, red was the
prime choice. The explorer-adventurer William B. Cabot
collected this hat in the early twentieth century. T880 (L)

Mittens (Montagnais)

94-38-10/87064 Length 24 cm.

An elaborate floral design embroidered with bundles of moosehair
adorns these caribou skin mittens. Commercial rickrack was
applied to the wrist area. They were collected in southern Quebec
in 1892. T1285

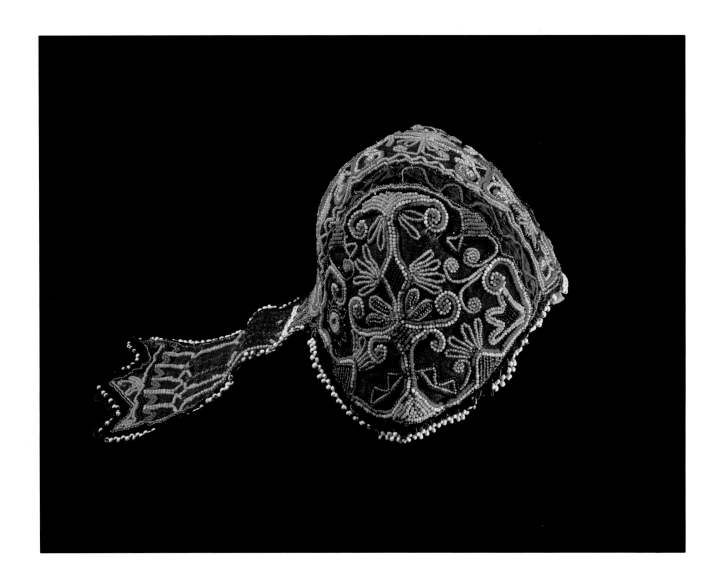

Baby's Christening Cap (Penobscot?)

41-72-10/24404 Length 20 cm.

A double-curve motif is apparent in the beadwork of this cap
which is made up of three pieces of red wool cloth edged by black
silk sewn with cotton thread. The lozenge and diamond design on
the back flap is suggestive of Penobscot work, and the beads are of
late nineteenth century date. The cap was accessioned in 1941 as
part of the David I. Bushnell Collection. T1224

Pouch (Southeastern Ojibwa)

99-12-10/53071 Length 65 cm.

Porcupine quill embroidery including a thunderbird motif adorns
this early nineteenth century pouch. The blue color is from indigo
and the orange from blood root. It was originally part of the
Boston Museum Collection. T137 (R)

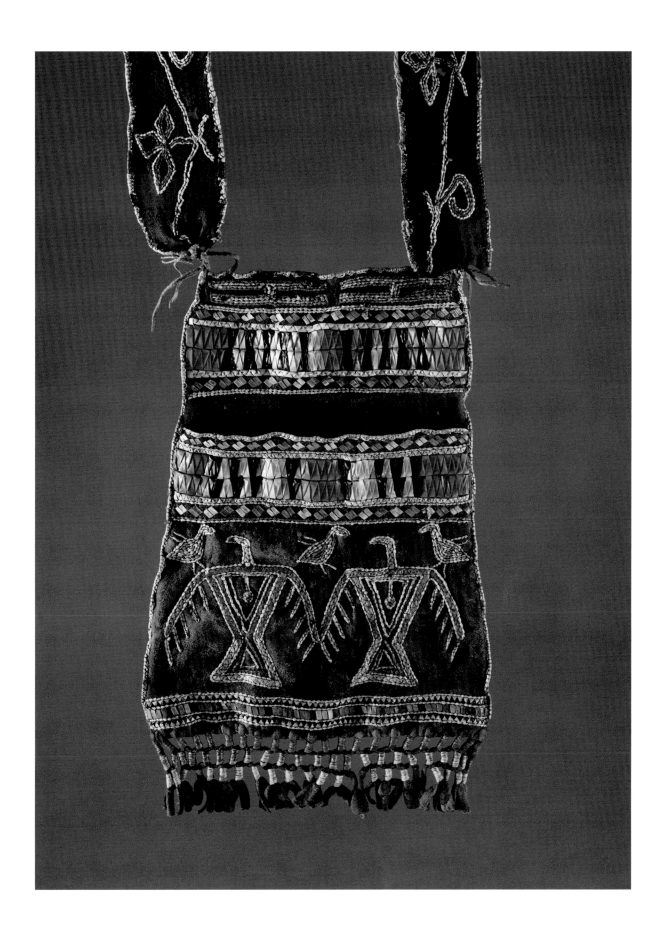

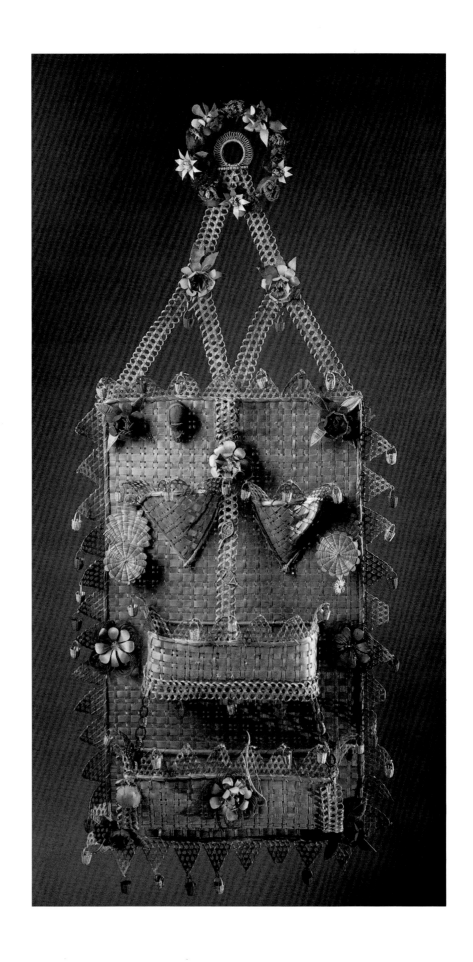

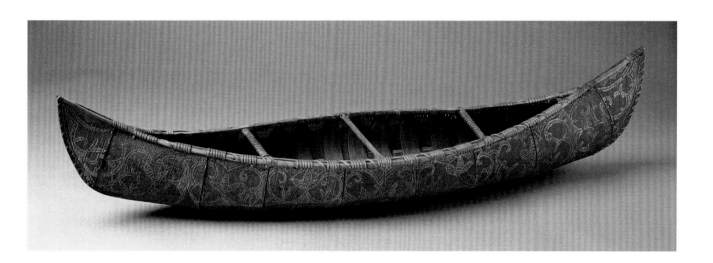

Fancy Wall Pocket (Maliseet)

94-38-10/52510 Length 103 cm.

This pocket was commissioned for exhibition at the 1893 World's
Columbian Exposition in Chicago, and reveals an "art for sale"
theme. The basket form and style is European, but the materials
and technique are purely aboriginal. T1292 (L)

Canoe Model (Passamaquoddy)

94-19-10/51055 Length 68 cm.

Although received by the Peabody Museum in 1894, this
birchbark canoe model dates to the early 1800s. A double-curve
design, engraved by a negative process, adorns the entire exterior
surface. It is rare, however, to have decoration occurring on the
bottom of a full-scale canoe of this type. T1279

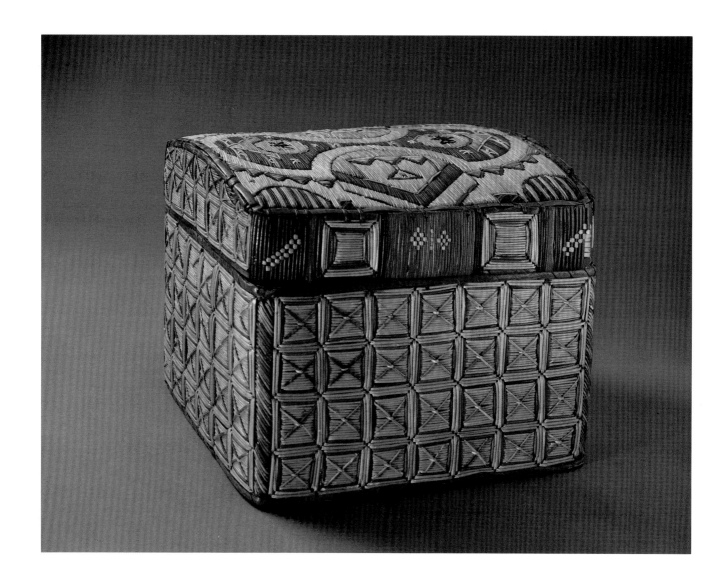

Birchbark Box (Micmac)

20-14-10/87633 Width 22.5 cm.

The base of this trunk top box is wood. Its walls are fashioned out
of single bands of birchbark sewn together with spruce root.
Quillwork covers almost all of the exterior surface. The decorative
patterns applied to such boxes were probably learned directly from
the Ursuline nuns of Quebec. This box is reported to have been
collected in New Brunswick in 1829. T1280

Southeast

Woman's Outfit (Seminole)

36-49-10/6121 Length 91 cm.

This green silk cape and vari-colored skirt was a typical dress in the period 1930-1950. The zoologist Thomas Barbour collected it from among the Mikasuki Seminole in 1936. It is unused and was apparently made to order. T1206 (L)

Blouse (Shawnee)

50-69-10/32711 Width 112 cm.

This is an example of a standard Eastern woman's blouse from which the Seminole cape is derived. The collar is also similar to those found on Seminole men's shirts. The brooches are made of German silver. The blouse, of red cotton, was made by the Shawnee of Oklahoma and probably dates to the late nineteenth century. T1204

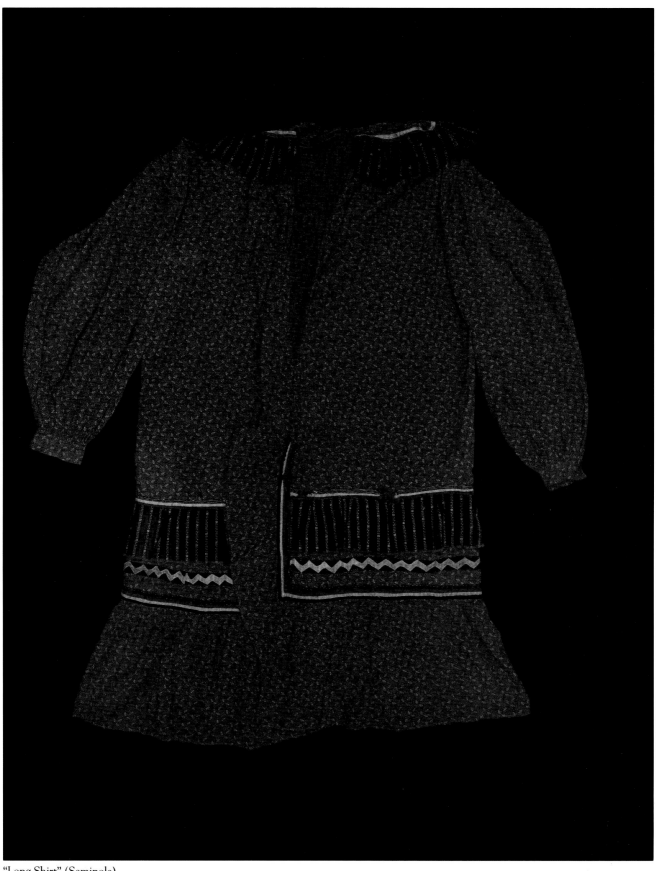

"Long Shirt" (Seminole)

20-8-10/87630 Length 117 cm.

The "long" shirt shown here was probably worn with front open, over a "plain shirt" as part of the same outfit. It was collected, together with a plain shirt, by Thomas Barbour in 1920 while he was visiting the Cow Creek Seminole. T1208

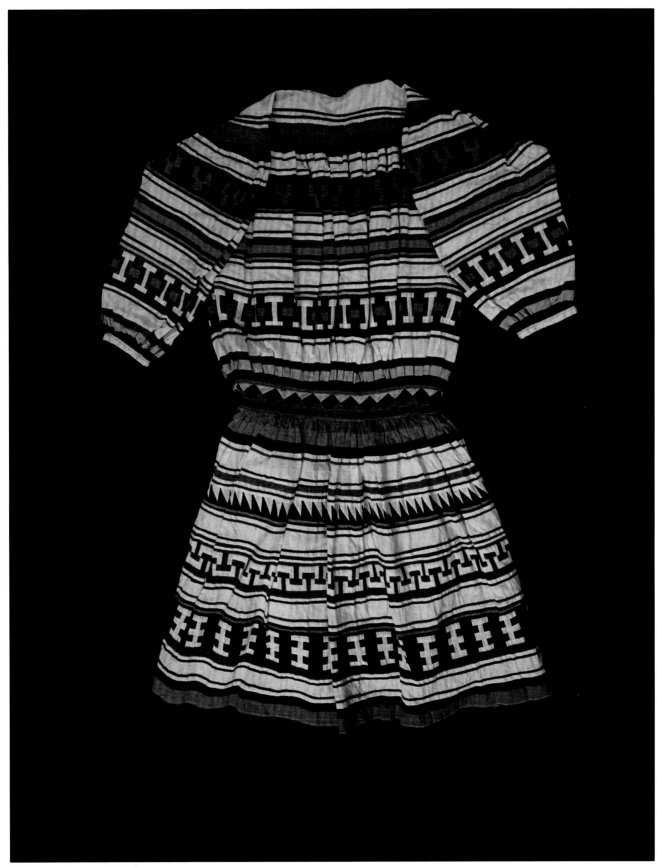

"Big Shirt" (Seminole)

36-49-10/6120 Length 115 cm.

"Big shirts" began to appear among the Seminole around 1900 and eventually replaced the long shirt/plain shirt combination. The earliest big shirts were plain, but patchwork bands became commonplace after 1915. This big shirt was collected in 1936. T1050

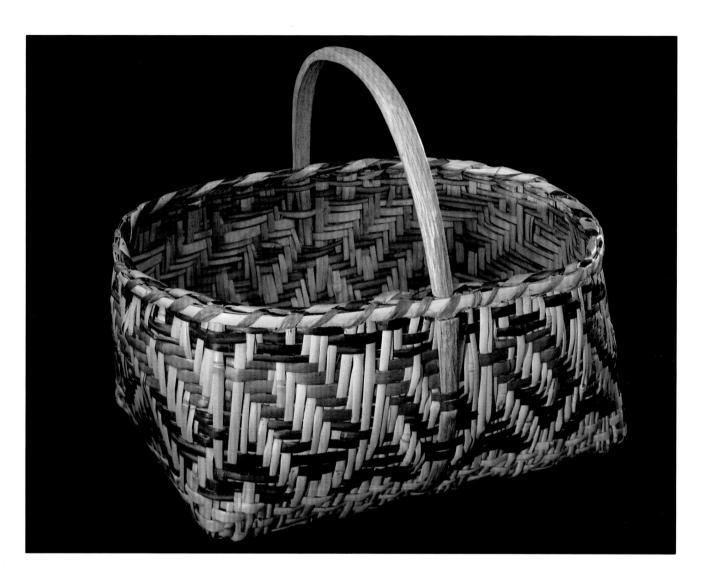

Turban (Seminole)

36-49-10/6122 Height 55 cm.

This turban is made of cotton and exhibits an egret plume. It was probably a model, since its form was already obsolete when it was acquired by Thomas Barbour from Deaconess Bedell in 1936. T1205 (L)

Market Basket (Cherokee)

08-17-10/73460 Height 21.5 cm.

This twill-plaited basket exhibits traditional manufacture and design except for the handle which is of Anglo-American derivation and is made of oak, steamed, bent into a curve, and then inserted into the weave. The anthropologist Mark R. Harrington collected this basket on the Qualla Reservation, North Carolina, around 1907. T1201

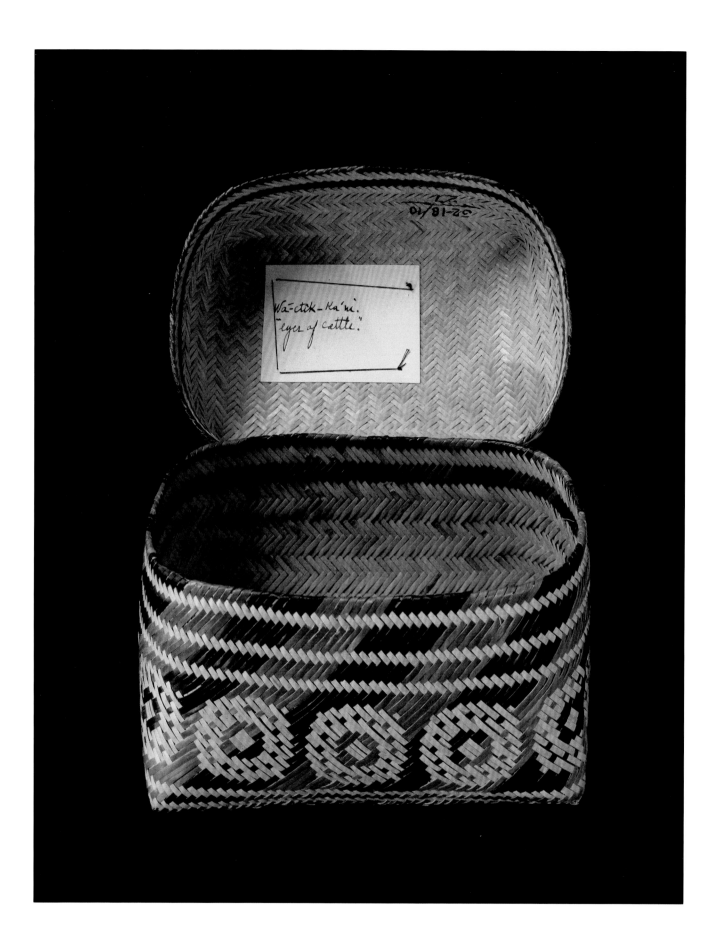

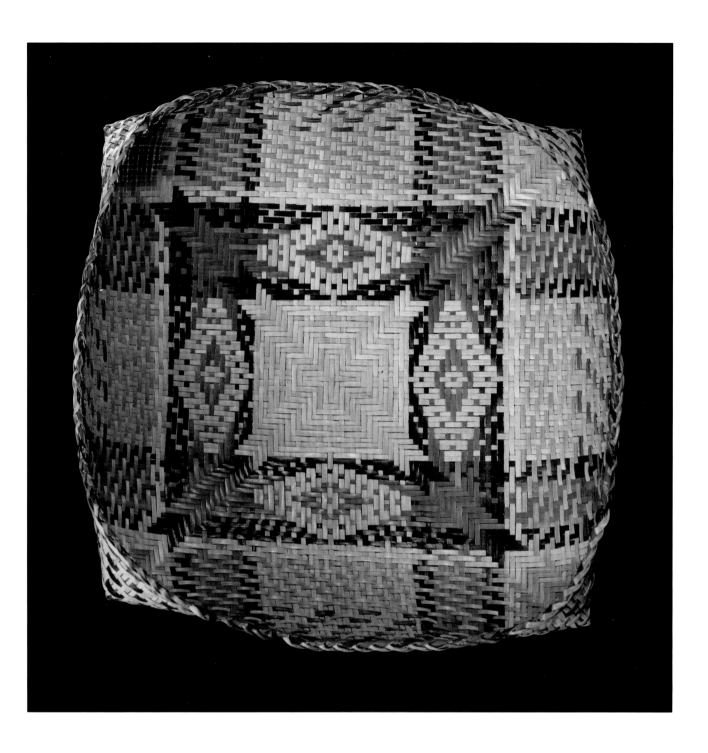

Trunk-shaped Covered Basket (Chitimacha)

32-18-10/27 Breadth 19 cm.

This double-layered basket was made by Clara Dardin around
1900, having been commissioned, together with others, by Mary
M. Bradford of Avery Island, who was trying to encourage native
crafts. The basket was made by plaiting from the bottom up, with
the shiny sides of the cane splints facing in. According to
informants, Dardin had a name for the design motifs used: this
one is called "eyes of cattle." T1202 (L)

Basketry Tray (Chitimacha)

02-13-10/57218 Width 21.3 cm.

Chitimacha baskets generally have complex decorations in various
colors made from vegetal dyes. The two most common colors,
black and red, were made by boiling black walnut root and
bloodroot respectively. This basket came to the Peabody Museum
in 1902. T1200

Southwest

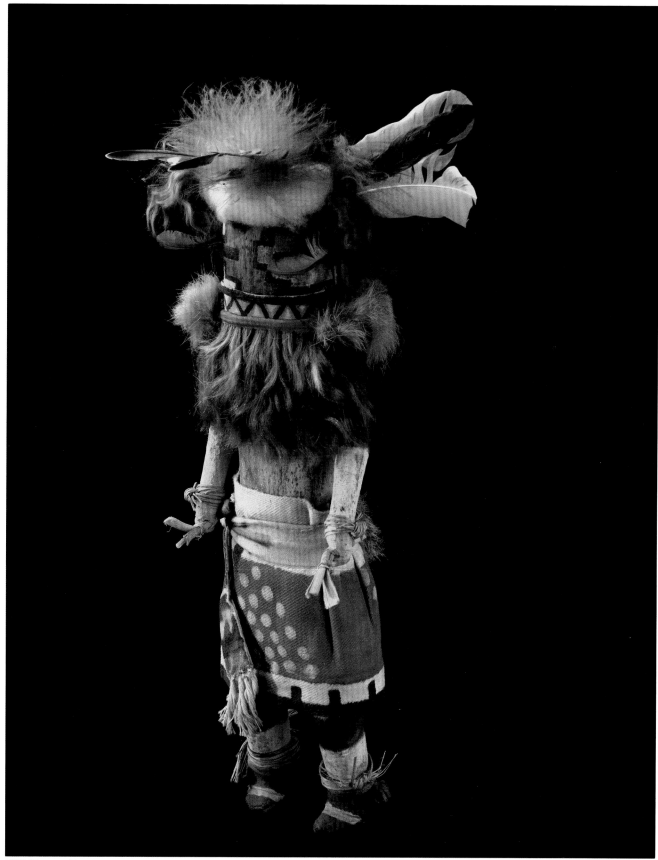

Hilili Katcina (Zuni)

05-7-10/64440 Height 37.5 cm.

Prior to 1900 very few Zuni *katcina* dolls were permitted to leave the pueblo. This changed briefly in the first decade or so of the twentieth century, but then public access was cut off until around 1935. This doll was acquired by the Peabody Museum in 1905. T1233

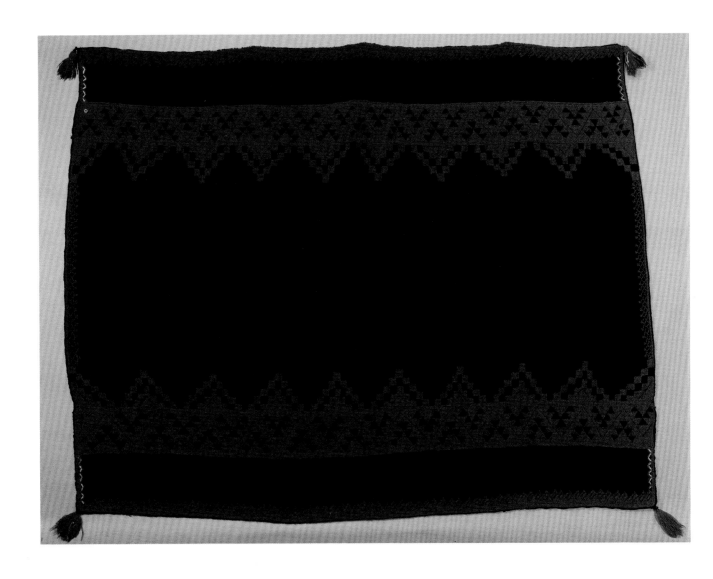

Dress (Zuni)

36-102-10/6248 Length 140 cm.

This dress, or manta, is a fine example of Pueblo weaving. It was probably woven by a man, since Pueblo weavers were primarily men, in contrast to women who are the principal weavers among the Navajo. It was the Pueblos who, in the mid-seventeenth century, provided the Navajo with the technical expertise necessary to develop their well-known weaving tradition. This dress dates to the 1890s or earlier. T1213 (Detail right)

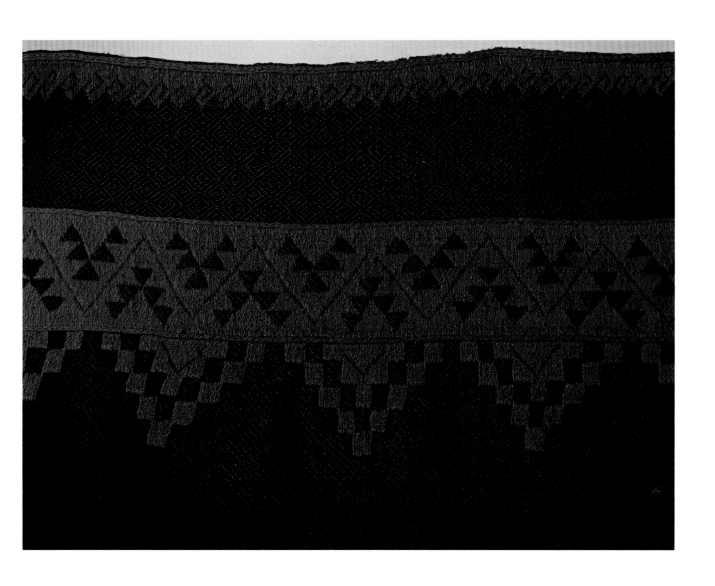

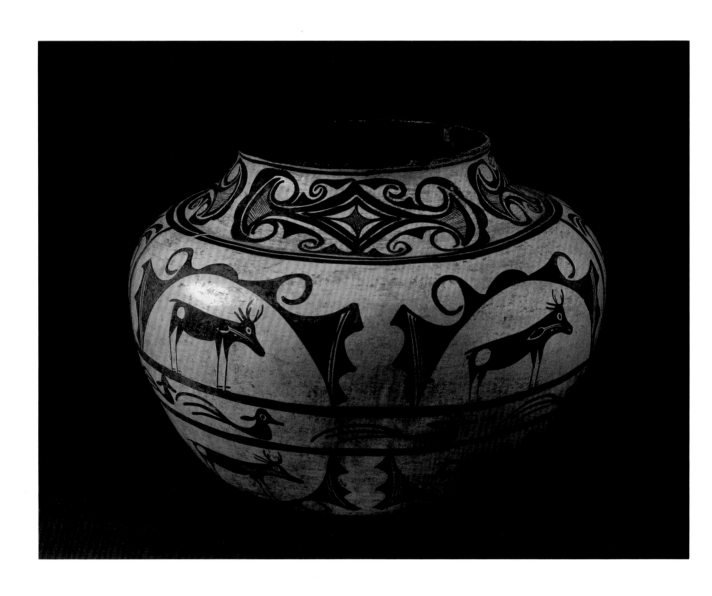

Jar (Zuni)

44-19-10/27354 Diameter 37 cm.

Zuni Polychrome vessels such as this were made between 1850 and 1890 for everyday use. They are characterized by a multicolored design broken into wide horizontal panels, the rim always being a different design from the body. This specimen was collected in 1879 by the ethnologist James Stevenson of the Smithsonian Institution's Bureau of [American] Ethnology. T1258

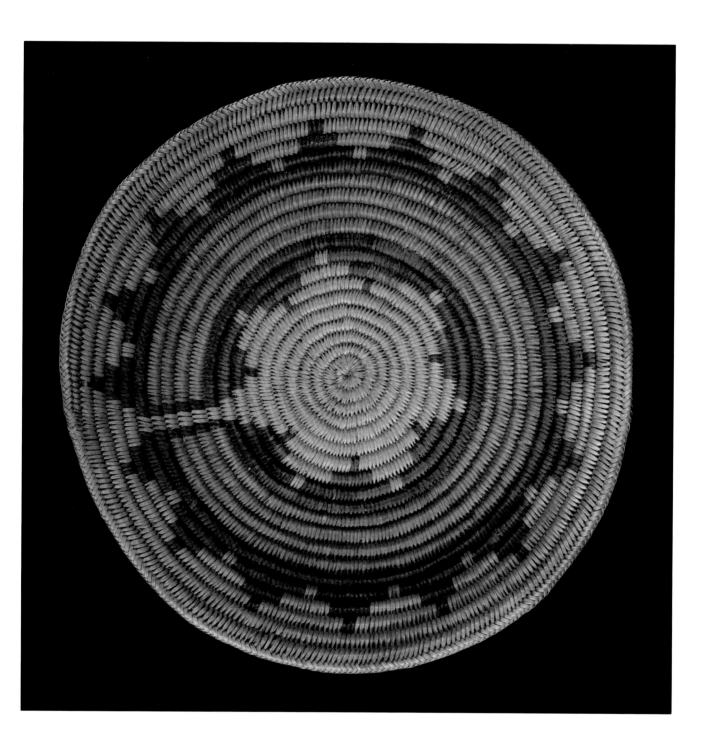

Wedding Basket (Navajo)

30-9-10/ 98459 Diameter 28.3 cm.

Wedding baskets usually served as containers for cornmeal mush and, despite the name, their ceremonial use was not restricted to weddings. This is the only Navajo basketry form to have survived after 1900. The opening seen in the design is a gap left purposefully, because it was believed that the spirit of the weaver could be captured if the design were closed. The opening would always be oriented to the east during ceremonies, so the notch on the outer rim enabled the handler to orient the basket in the dark. The collector Grace Nicholson acquired this basket in the early twentieth century. T1237

Blanket (Navajo)

985-27-10/58880 Width 184 cm.

The striped pattern in this example is characteristic of the "Chief's Blanket," worn as a sign of power and prestige. Such important blankets were often traded to other Indian groups in both the Southwest and the Plains. This style developed in the 1850s and was a standard type through the 1860s. This particular blanket was probably made between 1860 and 1865. It came to the Peabody Museum in 1985 as part of the William Claflin collection. T1217

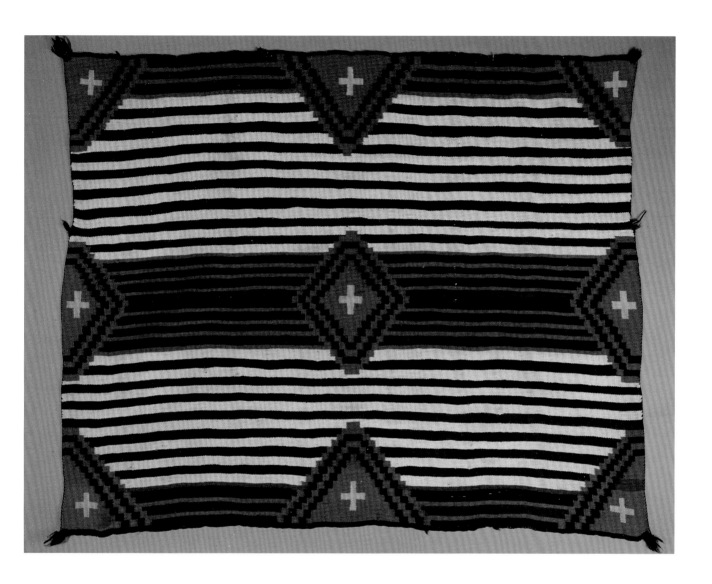

Blanket (Navajo)

60-2-10/38975 Width 136 cm.

The cross motif, which probably has its origin in Navajo basketry designs, appeared in weaving in the early 1860s. The small size of this blanket, in combination with the narrow black and white stripes, indicates that it was a woman's blanket. Men's blankets generally had wider stripes. General John Pittman collected this blanket during the 1880s. T1215

Blanket (Navajo)

32-27-10/58 Width 184 cm.

This Spanish-style blanket, called a serape, has a hole for the wearer's head woven in the center. The serrate diamond design is derived from weavings done in Saltillo, Mexico, but shows some variation since the diamonds were taken apart and used in zigzags and stripes. This blanket dates to about 1875. T1212

Blanket (Navajo)985-27-10/58879 Width 223 cm.

This blanket was woven in 1896 of bayeta, a red wool trade flannel that was unravelled by the weavers and then rewoven. It has a Classic period design that was copied from patterns especially made for reproductions. Originally owned by Lorenzo Hubbell of Ganado, Arizona, this blanket came to the Peabody Museum in 1985 as part of the William H. Claflin collection. T1216

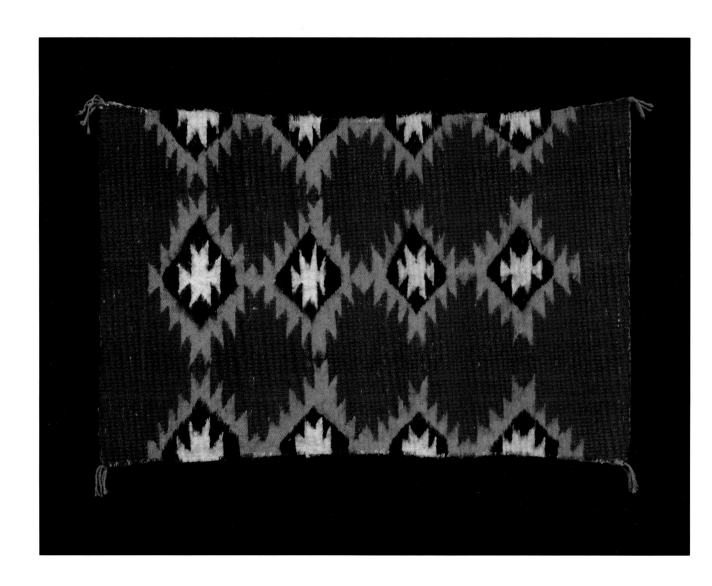

Saddle Blanket (Navajo)

01-14-10/56763 Width 112 cm.

By the late 1800s nearly all Navajo weaving was produced for sale to tourists and collectors. The saddle blanket is one of the few textiles that the Navajo continued to make for themselves. Using wool colored with aniline dyes, it was woven in a double-faced weave, thus producing different designs on either side. The large size of this particular blanket indicates a double saddle blanket. Frederic W. Putnam, Director of the Peabody Museum, purchased this blanket in 1901. T1209

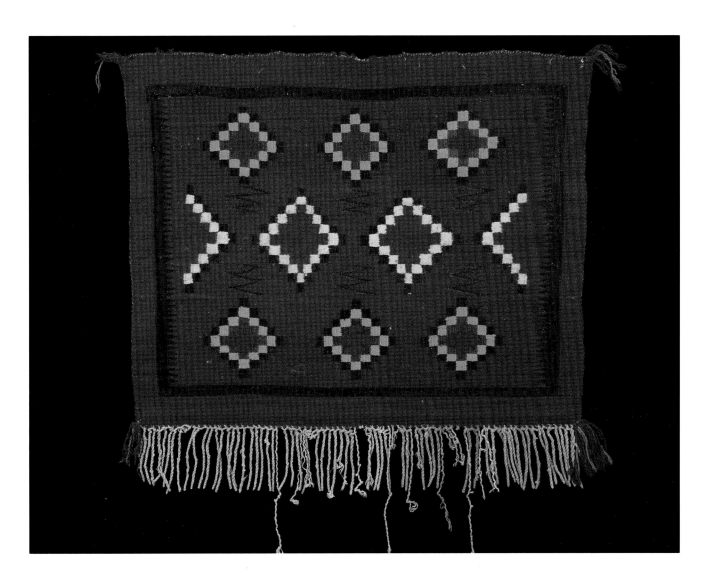

Saddle Throw (Navajo)

23-27-10/98019 Width 76 cm.

Whereas a saddle blanket goes underneath the saddle, a throw is used on top of the saddle for decorative purposes. Navajo women wove such throws as gifts for their future husbands. Production of these blankets began in the 1870s. This one was collected in 1888-1889 and was probably woven about that time. T1211

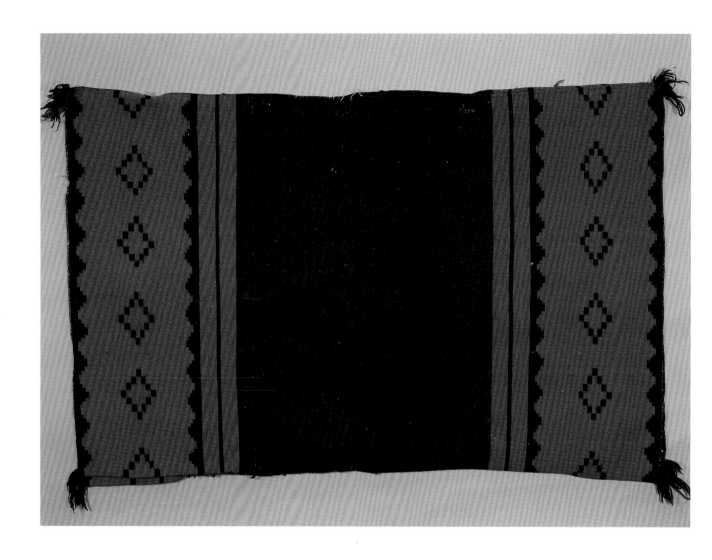

Dress (Navajo)

38-98-10/13058 Length 127.5 cm.

This dress is constructed out of two blankets sewn together at the
shoulders. The two-piece form replaced the one-piece outfit by
the late 1700s and was probably derived from deerskin dresses or
Spanish-style serapes. The terraced diamond motif in the fabric is
also present in contemporary Navajo basketry designs. This dress
dates to about 1870 and was bought from the Fred Harvey
Company in 1919. T1214

Basketry Tray (Hopi)

45-25-10/28644 Diameter 33.5 cm.

This fine wicker tray may have been used in certain ceremonies to
hold *piki*, a thin, wafer-like cornmeal bread. Some of the finest
wicker work was (and still is) produced on Third Mesa, the
principal village of which is Oraibi, where this tray was made. It
was collected by Thomas V. Keam in the late nineteenth century
and purchased from him in 1892 by J. Walter Fewkes, Director of
the Second Hemenway Expedition. T1251 (R)

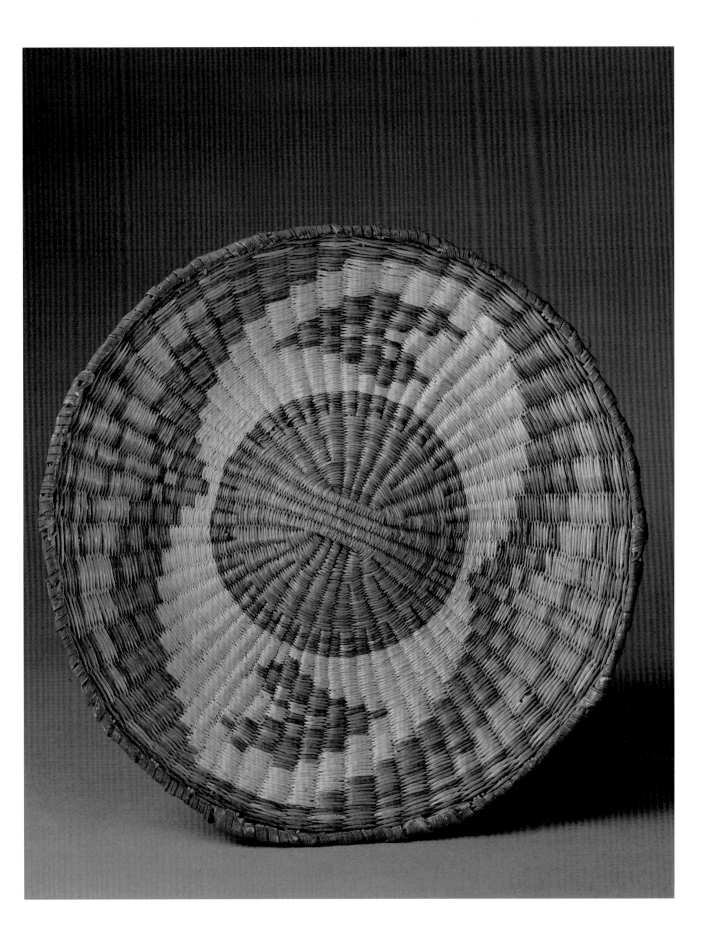

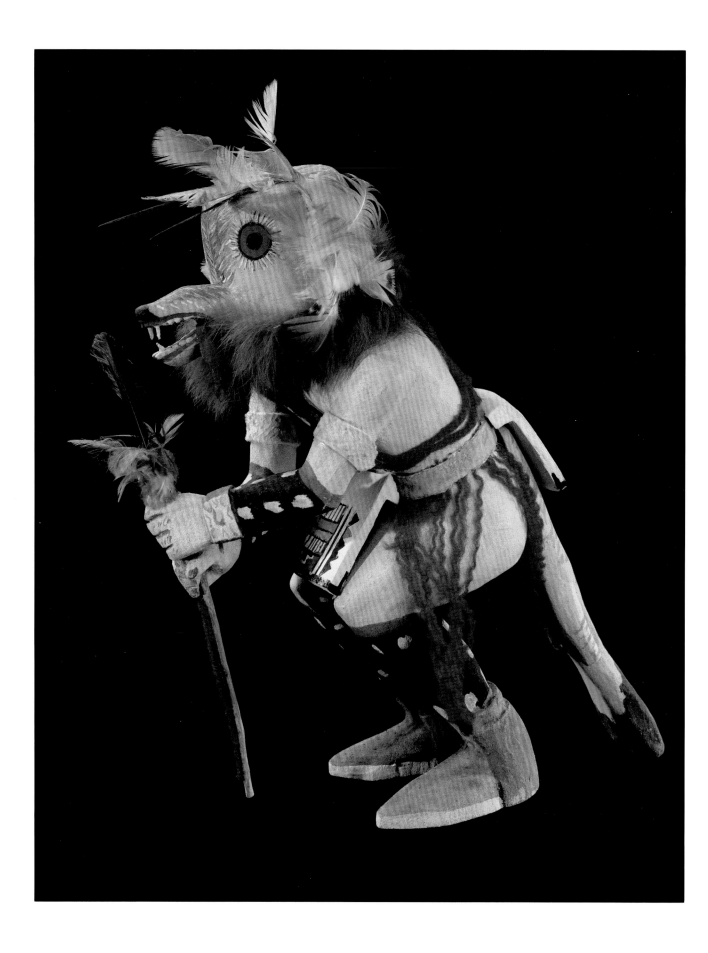

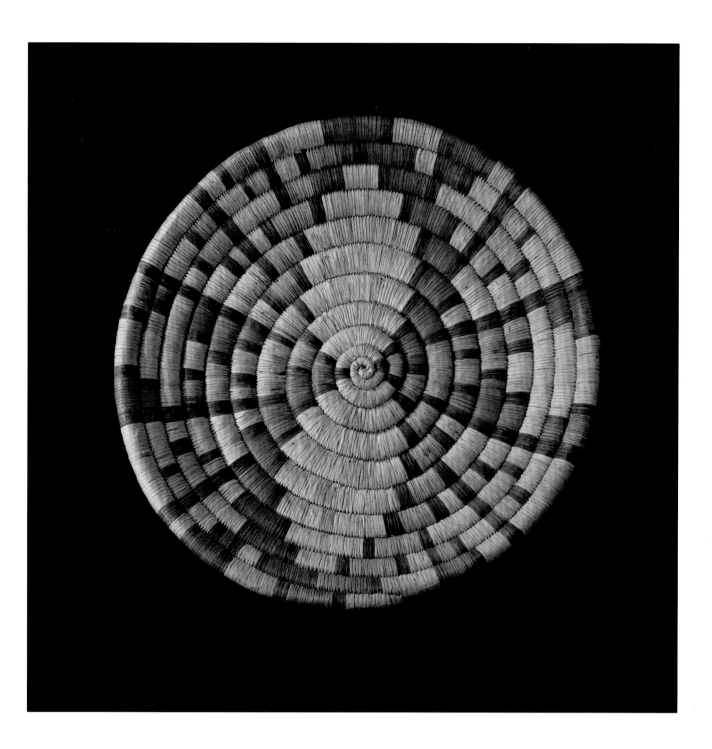

Kwewu, Wolf *Katcina* (Hopi)

981-21-10/58607 Height 27.5 cm.

This doll was collected in 1940 by Mischa Titiev and shows some
of the features common to modern *katcina* dolls. Older examples
of the *Kwewu* show less movement and the clothing and
decorations are far simpler. This doll has feet which support it
freestanding, a change brought about by tourist demands.
T1240 (L)

Basketry Plaque (Hopi)

16-20-10/86706 Diameter 34 cm.

This bundle-coiled plaque, or tray for corn meal, was made at
Hopi on Second Mesa. The thickness of the coils serves as a
rough indicator of when the plaque was made, thicker coils (as
here) being generally earlier. This plaque came to the Peabody
Museum in 1916. T1236

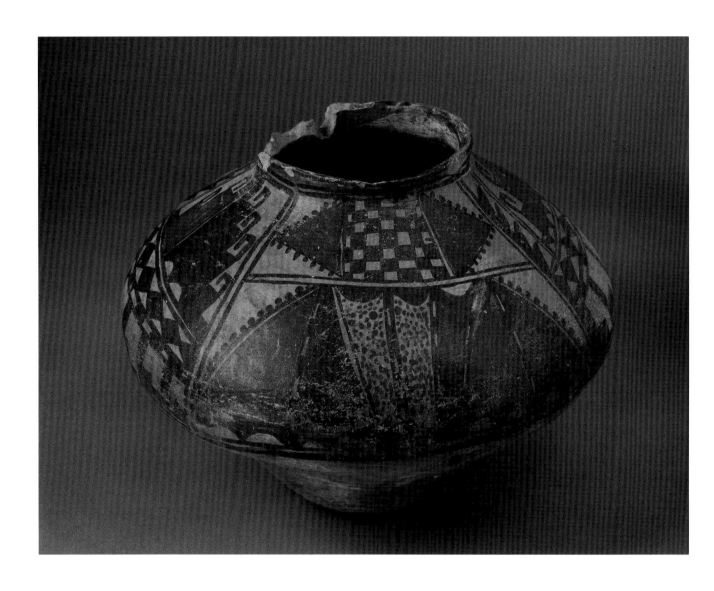

Jar (Hopi)

43-39-10/25143 Diameter 24.6 cm.

This jar, an example of the type Payupki Polychrome-on-orange, is
typical of what some Hopis were making for their own use
between 1680-1780. T508

Vase (Hopi)

42-6-10/23610 Height 21.6 cm.

The shape of this vessel indicates that it was made for tourists, as
it is not a traditional shape but was probably developed as a base
for table lamps. It was made by Maud Namoki in 1938 or 1939.
T1293 (R)

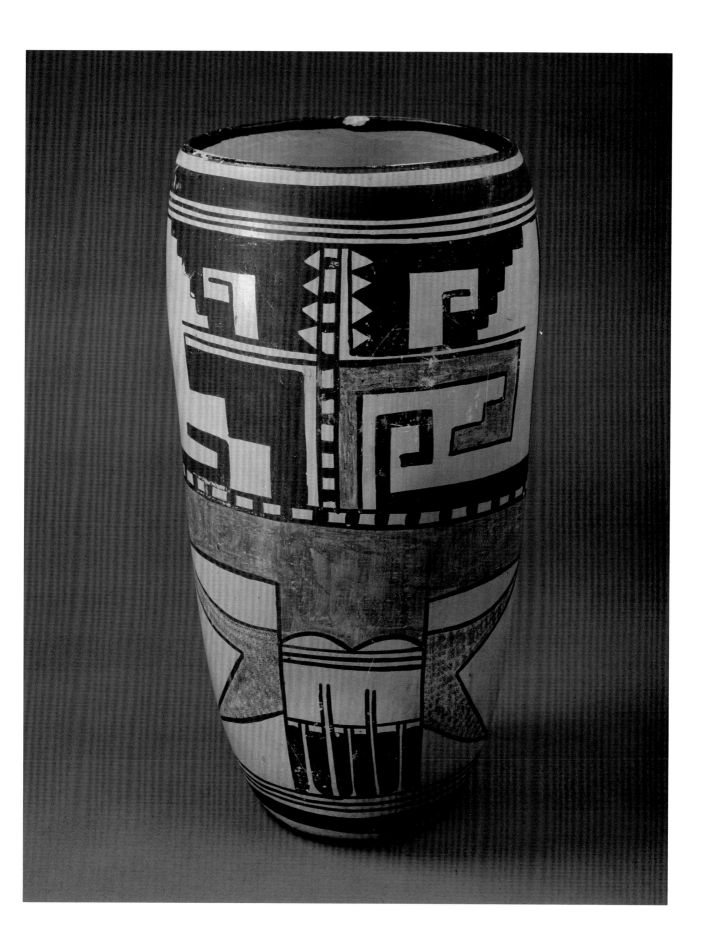

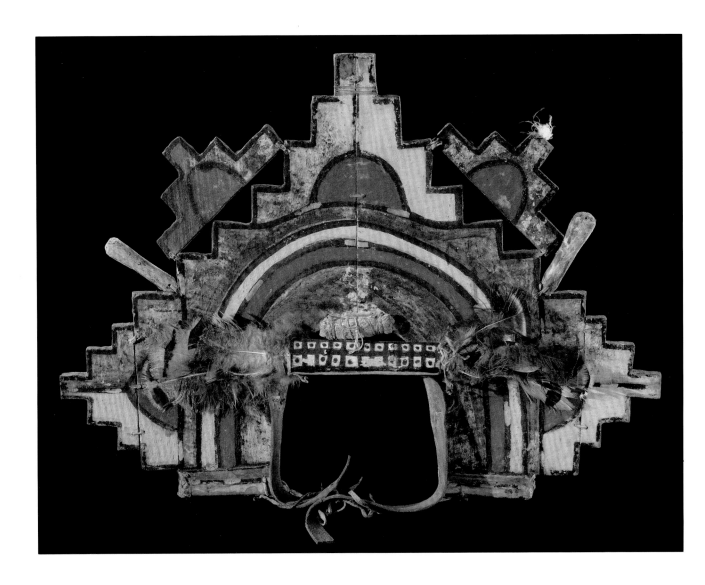

Tablita (Hopi)

45-25-10/28713 Width 59.5 cm.

This tablita, made of painted wood, was worn by the person acting the part of *Palahi*, who appears in the woman's ceremony called *Mazrauti*, held in October. The central piece crossing the forehead represents corn, while the piece above it is the husk.

Thomas V. Keam collected this object before 1892, when it was purchased by J. Walter Fewkes for the Second Hemenway Expedition. T1239

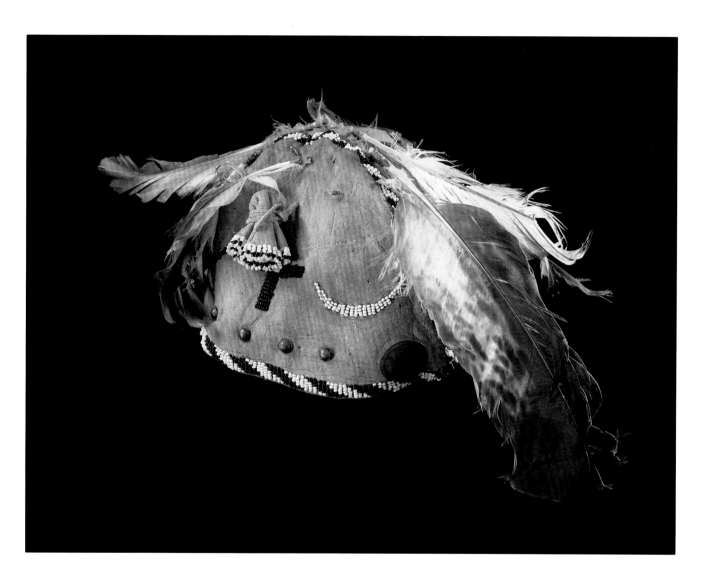

Cap (Chiricahua Apache)

15-14-10/86209 Height 18 cm.

Apache war caps usually consisted of a skin skull cap with feathers (often from an owl) and some beaded designs, which on this example represent astronomical figures. The little bundle probably contains pollen or some other medicine. Navajo silver buttons are typically attached to such caps, which the Navajo also wore. This one was collected by Grace Nicholson and dates to the 1880s. T1235

Bowl (Acoma or Laguna)

95-21-10/48490 Diameter 34.5 cm.

The thin walls of this bowl suggest that it was made at Acoma
rather than Laguna, but the two pueblos produced very similar
styles of pottery. The bowl exhibits several characteristics which
indicate significant Spanish influence: the interior design may
have been derived from Majolica, a tin-glazed earthenware
produced in Spain and Portugal. The annular base and carinated
rim are also derived from Spanish vessels. The bowl was produced
for Pueblo use sometime between 1850 and 1895. T1288

Doll (Mojave)

12-29-10/84105 Height 25 cm.

This figurine was not necessarily made for children, and its
specific function is unknown. The beads in the ears were popular
in the late 1800s. The collector Grace Nicholson acquired this
object in 1912. T1234 (R)

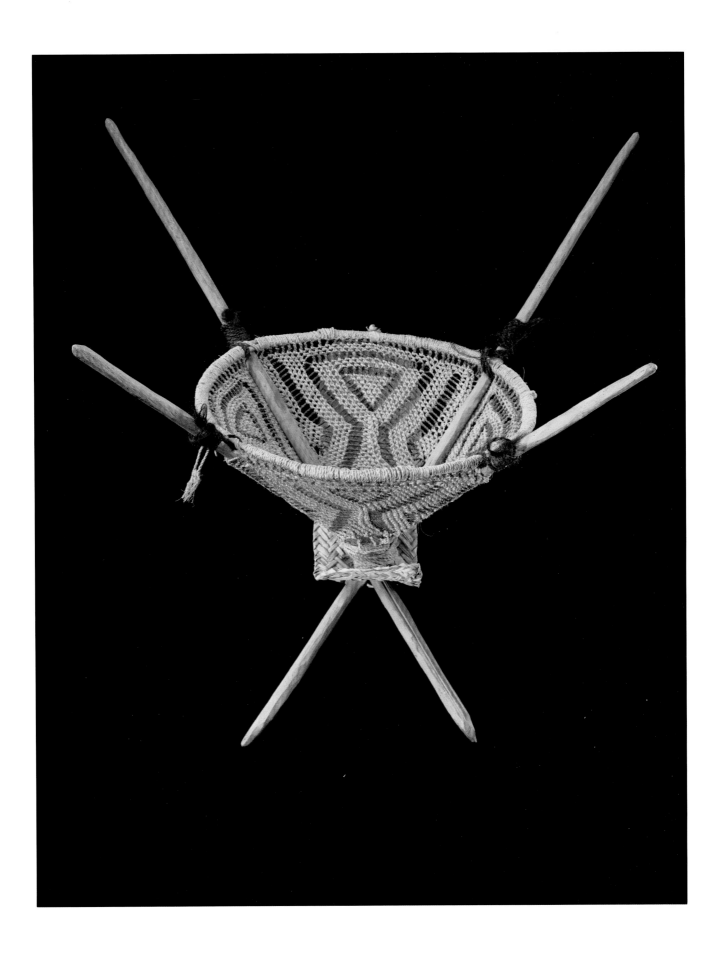

Carrying Frame (Pima)

02-14-10/62008 Height 77 cm.

A frame such as this was carried on the back, supported with the aid of a tumpline tied around the forehead. Carrying frames were usually employed in gathering firewood, although this one is too small for that purpose. It was made prior to 1902. T1232 (L)

Cradle (Mescalero Apache)

02-14-10/62193 Length 90 cm.

This cradle is a variant of a general Southwest and California type. The frame is a bent wooden rod, which is then filled with flat wooden strips as a backboard. Its covering is a combination of cloth and native tanned leather. The daubing of yellow ocher is typical of Mescalero Apache work. Small, shiny objects were often attached to these cradles to amuse the baby. This cradle dates prior to 1902. T1210

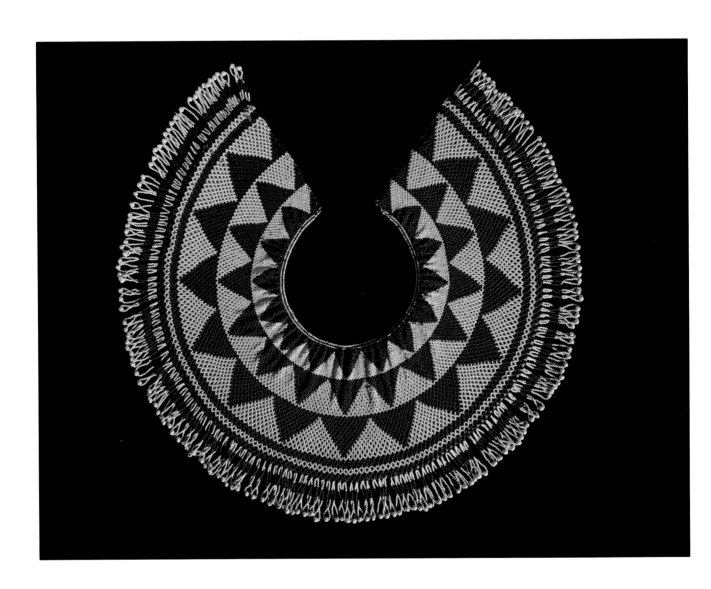

Collar (Mojave)

44-40-10/27487 Diameter 55.5 cm.

This beaded collar is one of the few objects in the Southwest to be
made by a netting technique. They were worn by women on
ceremonial occasions, with blue and white being the traditional
colors. This one was collected about 1890. T1238

California

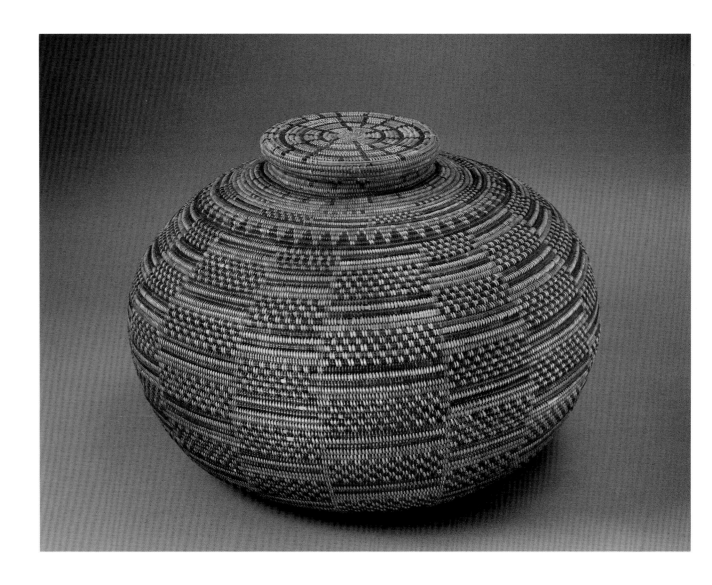

Basketry Jar (Chumash)

13-23-10/84678 Height 40 cm.

This is one of the most rare North American Indian baskets in
the Peabody Museum. In terms of shape, color, and design, it
represents Chumash workmanship at its peak. It was collected
prior to 1837, but could even predate the nineteenth century.
T1221

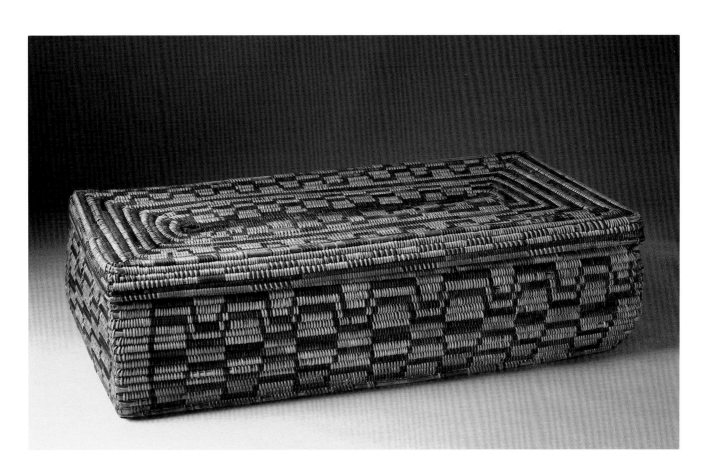

Sewing Basket (Chumash)

32-54-10/177 Length 45 cm.

The rectangular shape of this basket is not indigenous: it was
probably used as a sewing basket and is extremely rare. It was
collected in the Chumash region prior to 1835. T1277

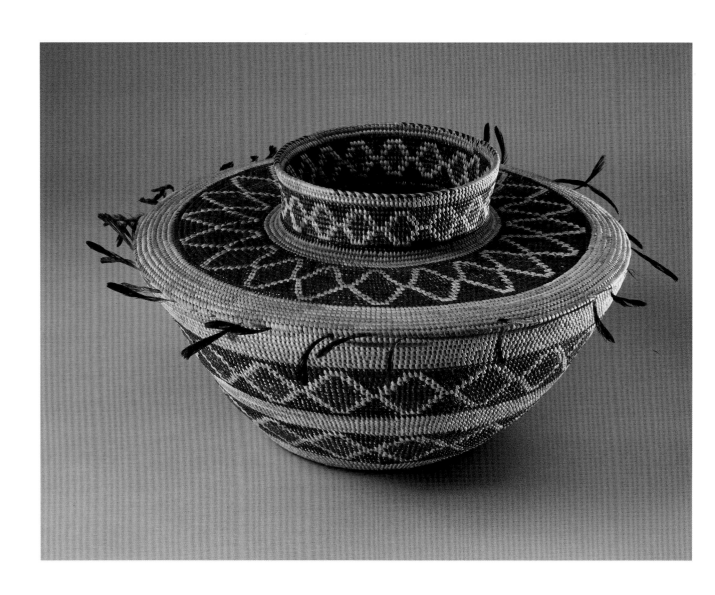

Feather Basket (Yokuts)

34-118-10/3788 Diameter 32 cm.

This olla-shaped basket is of coiled construction, with California
Valley quail feathers adorning the shoulder. The black stitches are
bracken fern, the tan are slough-grass, and the red are redbud.
The basket was collected in 1897. T1278

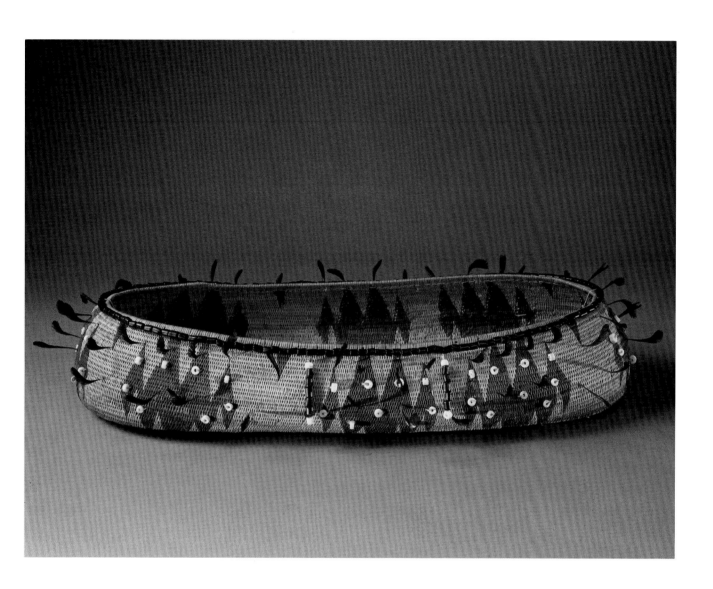

Elliptical Basket (Pomo)

20-13-10/87599 Length 50 cm.

This coiled basket is made of willow, decorated with sedge,
bracken fern and redbud stitches. The black plumes are California
Valley quail. The beads are glass of European manufacture and
were substituted for indigenous clam shell beads. The basket came
to the Peabody Museum in 1920. T1276

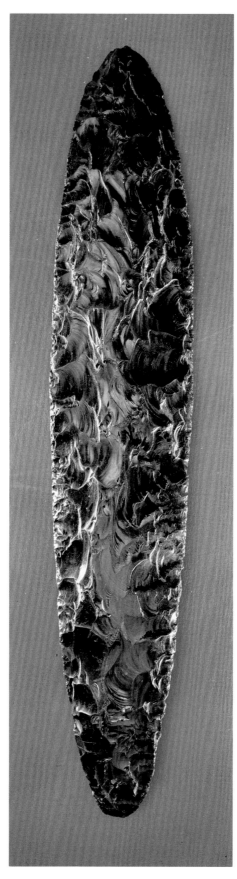

Obsidian Blade (Klamath River Region)

94-57-10/R513 Length 46 cm.

These two blades were collected by Frederick H. Rindge at the end of the nineteenth century.
They are integral features of the White Deerskin Dance, at which they are displayed
as symbols of wealth and social prestige. T1222

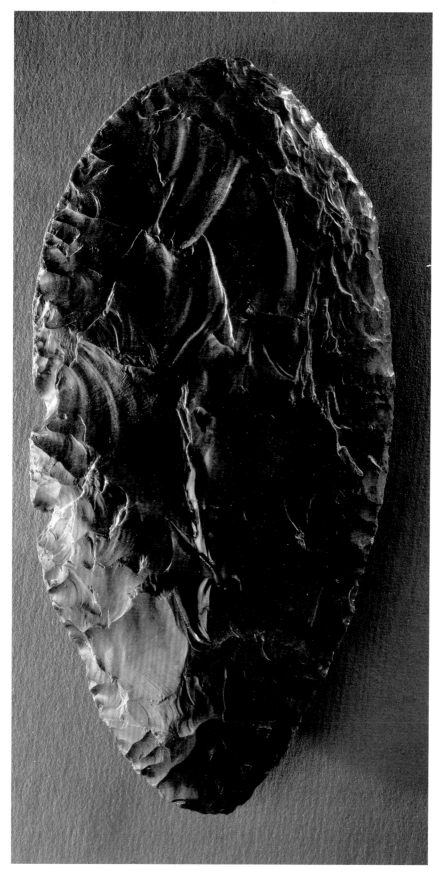

Obsidian Blade (Klamath River Region)

94-57-10/R2100 Length 22 cm.
Red obsidian blades are always smaller than the black, but are more highly valued. The
obsidian comes from northeast California and adjacent portions of Oregon. T1223

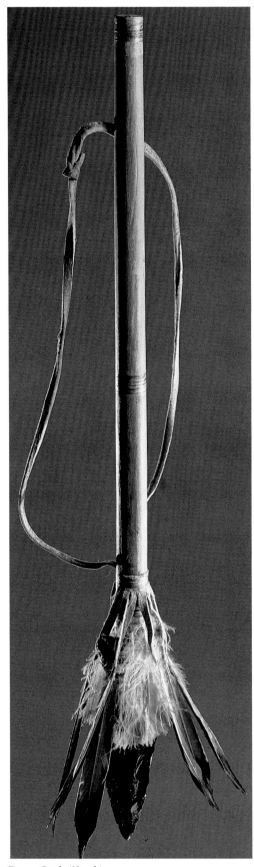

Dance Stick (Karok)

08-4-10/73342 Length 53 cm.

This dance stick, used in the 1903 War Dance of the Karok, has a point of obsidian, beneath which are flicker feathers and eagle down trim. Grace Nicholson and Carroll Hartman collected this object. T1219

Dance Plumes (Hupa)

06-5-10/66480 Height 71 cm.

Plumes are worn on the heads of men in the White Deerskin Dance. Flicker feathers tied by sinew are here adorned at their bases with
eagle down. The collector Grace Nicholson acquired these plumes in 1906. T1218

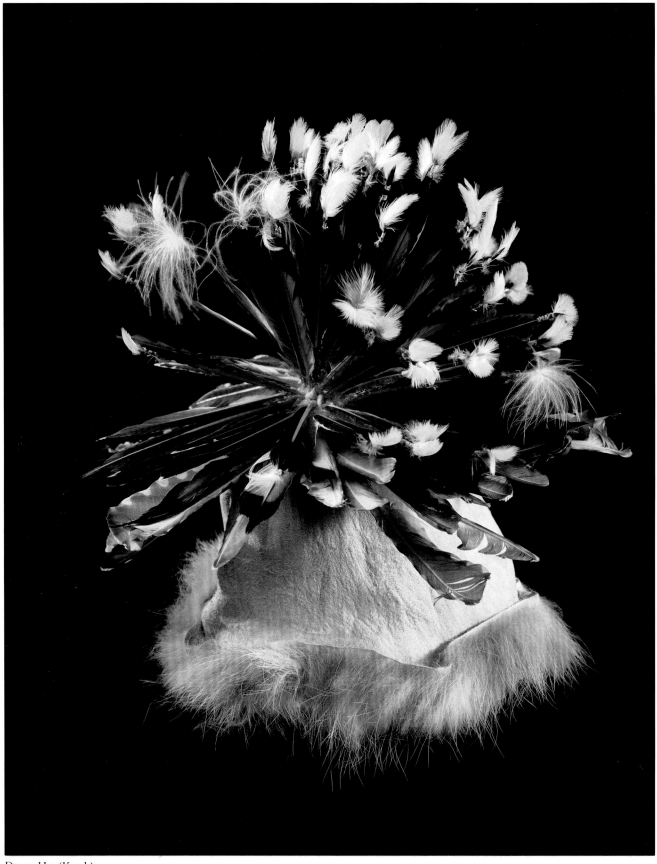

Dance Hat (Karok)

08-4-10/73364 Height 19 cm.

This hat was worn in the secular Brush Dance. A cap made of deerskin carries on the crown a crest of flicker feathers tipped with yellow breast feathers from the gold finch. The hat was collected by Grace Nicholson and Carroll Hartman in 1908. T1220

Great Basin and Plateau

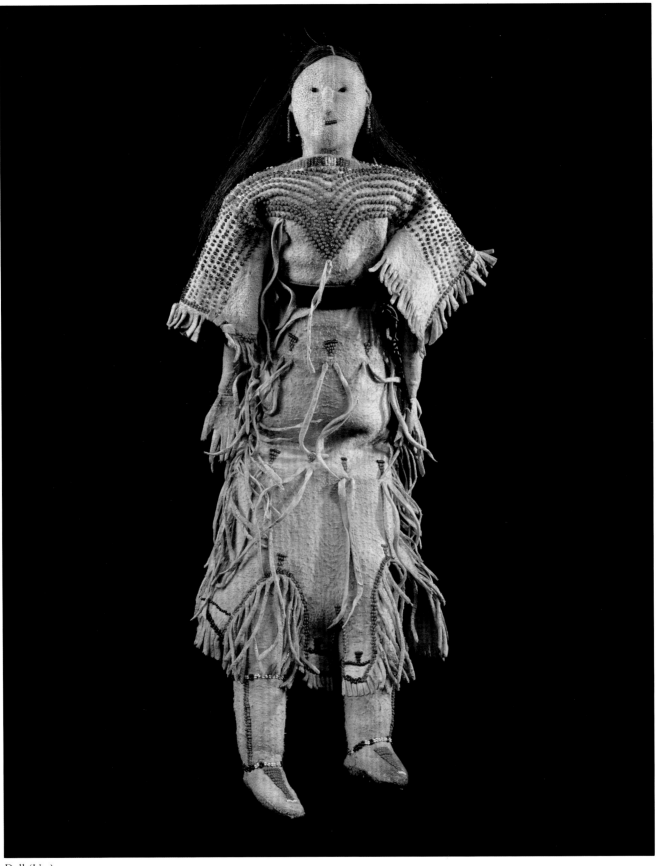

Doll (Ute)

05-53-10/65715 Height 46 cm.

The Ute were heavily influenced by Plains Indians, as revealed by the pattern of this doll's clothes. Ute dresses of the nineteenth century were made of two deerskins, front and back, sewn down the sides, with fringes and shoulder flaps. T1255

88

Woman's Bag (Ute)

12-29-10/84383 Length 23 cm.

This bag, collected by Grace Nicholson in 1919, was probably used to hold personal items. The light blue and pink beads are identical to those used in the northwest Plains by the Crow, the "lazy stitch" technique probably came from the central Plains, while the geometric patterns are more of a southern Plains style. T1256

Bag (Nez Perce)

92-1-10/47791 Height 32 cm.

This twined sally bag has a leather rim and drawstring, as well as a leather carrying strap. The repeating geometric pattern is typical of Nez Perce basketry. The authropologist Alice C. Fletcher obtained this object in 1891 from James Stuart, a Nez Perce Indian. T1254

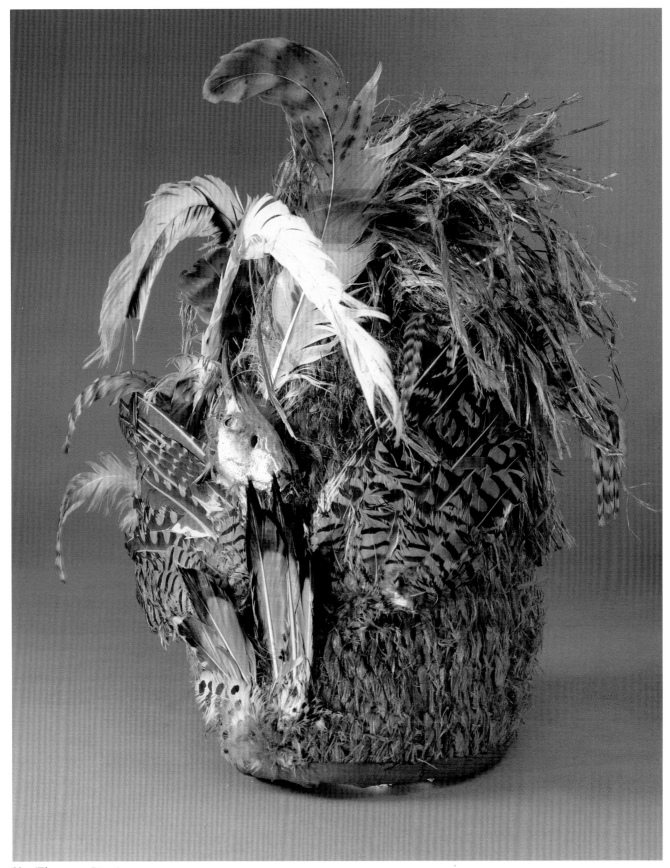

Hat (Thompson River)

15-36-10/86602 Height 40 cm.

This hat is made of woven cedar bark trimmed with birds and feathers, including those of the northern flicker. Commercial silk fabric was also used in its construction. The anthropologist James Teit collected this object before 1915. T1257

Plains

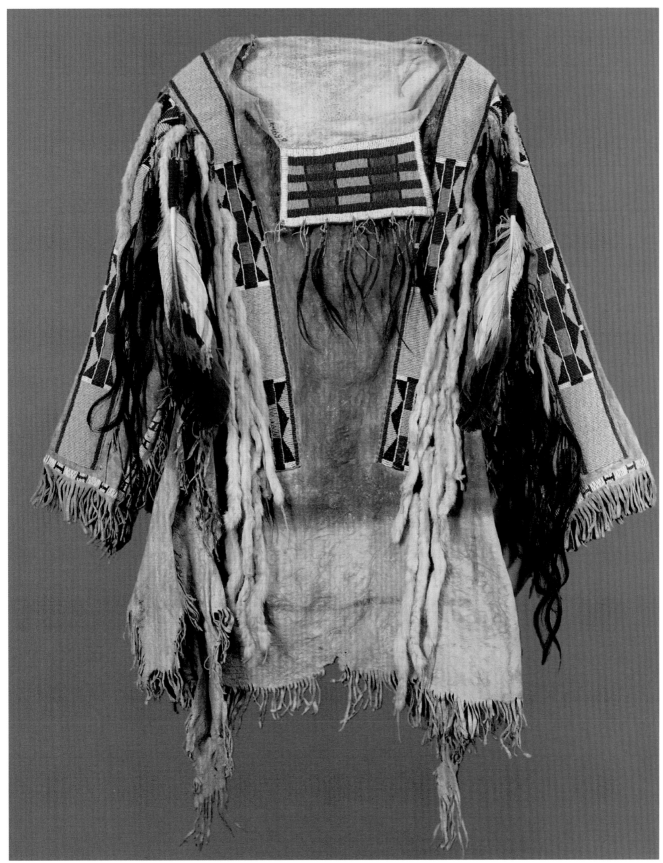

Shirt (Crow)

14-35-10/85928 Length 158 cm.

Fancy shirts like this were only worn on important social or religious occasions. The skin has been stained blue-green at the top, and yellow below. Decorations consist of ermine skins, hair tassels, and panels of beadwork. The shirt dates to the late nineteenth century.

T1249

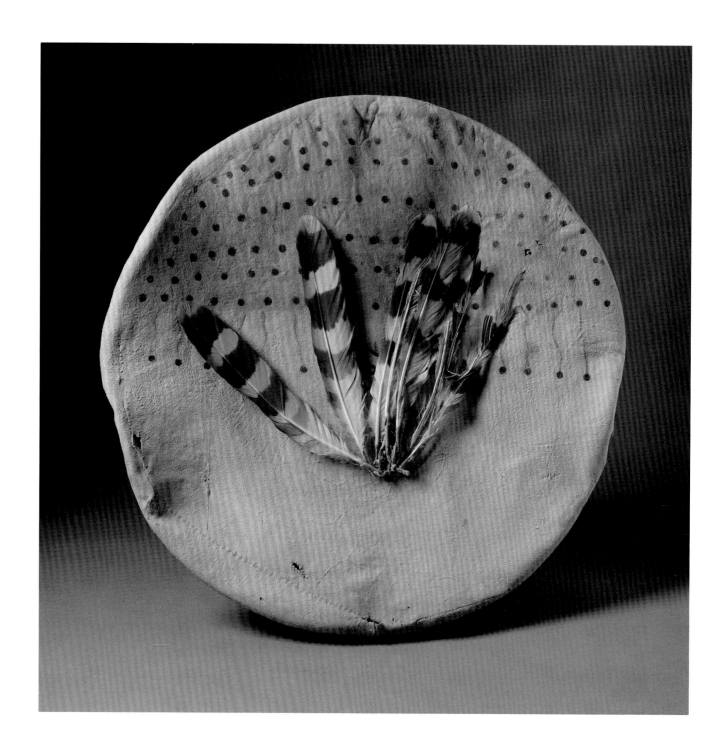

Medicine Shield (Crow)

05-7-10/64949 Diameter 50.4 cm.

Shields were made of layered, shrunken, bison hides. They were
important to Plains Indians for both spiritual and physical
protection. According to museum records, this shield belonged to
"Gray Bull," who was claimed to be the greatest fighting chief
alive at the time the shield was collected, sometime before 1905.
This is probably the same "Gray-bull" (1845-?), whose war
exploits were described by the anthropologist Robert H. Lowie in
The Social Life of the Crow Indians. T1294

Cradle (Crow)

05-7-10/65724 Length 134.6 cm.

This cradle is typical of those used among groups in the western
Plains and Rocky Mountains. It is made from a flat board,
narrowed at the bottom and with rounded ends. This was first
covered with skin, the beaded cloth panels having then been
added to the top and bottom. Beads were attached directly to the
wide straps that served to hold the baby in place. It probably dates
to the 1880s and is a good example of Crow beadwork of that
time. Typical characteristics are the pastel colors, the smooth
blending of the designs without ridges, simple massive geometric
figures with some small detail, and the tall, slender triangles.
T1274 (R)

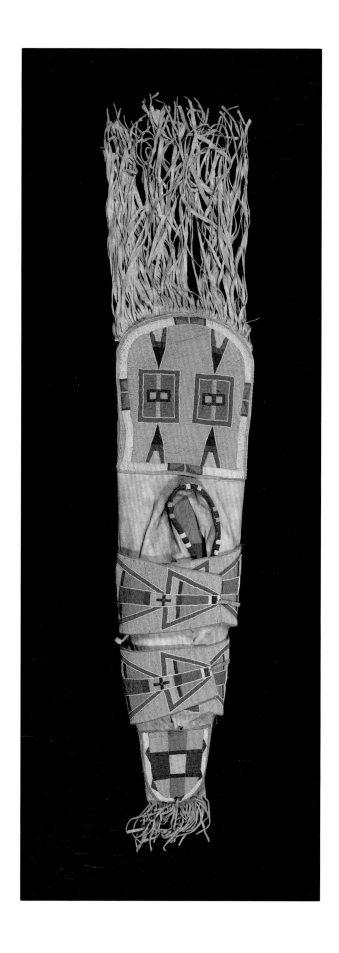

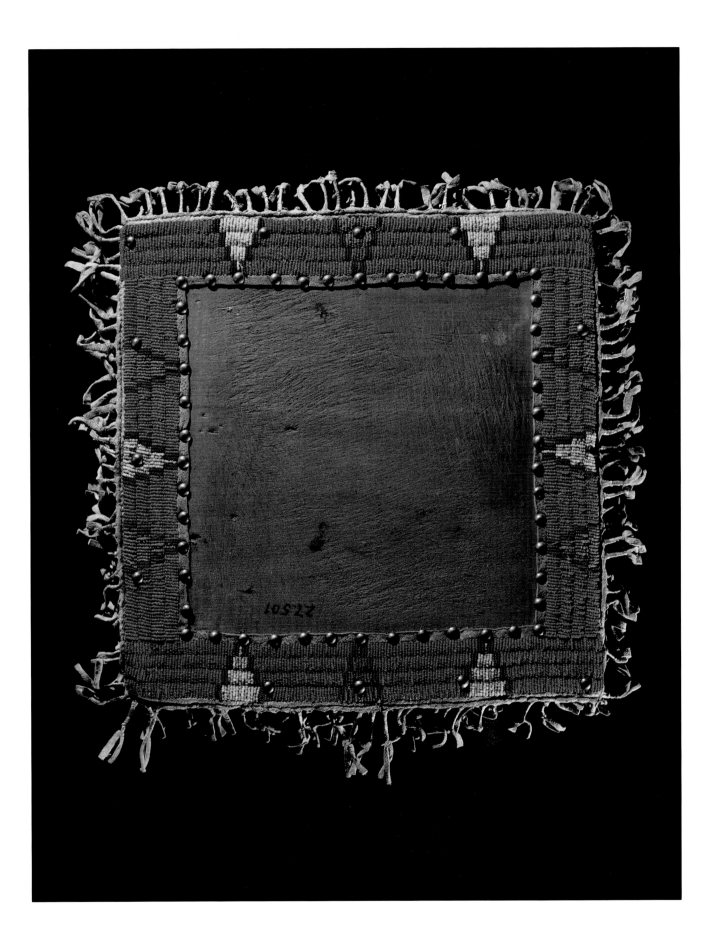

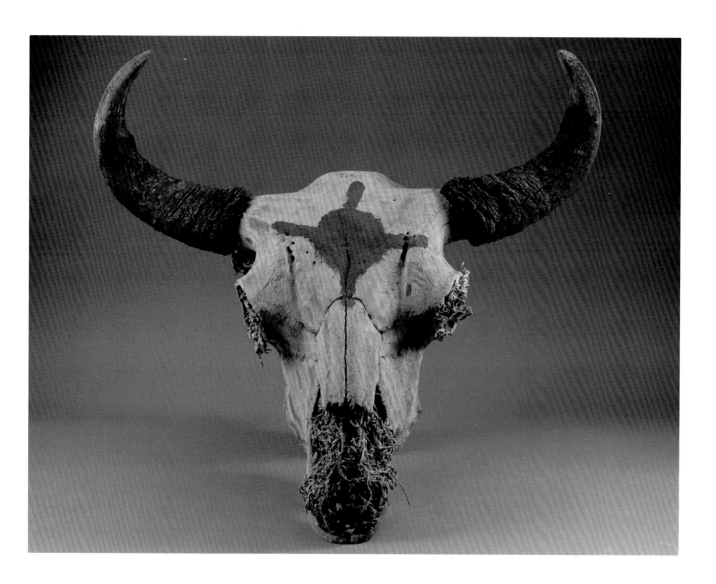

Consecration Board (Oglala Teton Sioux)

82-45-10/27501 Width 40 cm.

This board was used during the consecration ceremonies in the initial stages of the Sun Dance, 1882, probably for cutting the tobacco that was smoked at various times during the dance. Cut marks are still clearly visible on the surface of the wood, which came from part of a tobacco crate. The label on the back reads, "Inge & Mahone, Factory no. 17 Second District, Petersburg, Virginia." The border of beaded hide, with quill-wrapped tassels, is attached by brass-headed tacks. T1272 (L)

Painted Bison Skull (Oglala Teton Sioux)

82-44-10/27482 Height 77 cm.

On the fifth day of the Sun Dance, 1882, a bison skull was carried into the tent that had been set apart for the consecration ceremonies. Whereas the lodge represented the earth, the home of man, the bison skull altar symbolized the essence of life. It was placed opposite the central post and entrance to the tent. Only the dance leader and priest could occupy the space behind it. On the sixth day a symbol representing the four winds was painted in blue on the skull. The fibers within the nose are *artemisia* (sagebrush) commonly used in religious ceremonies. T1248

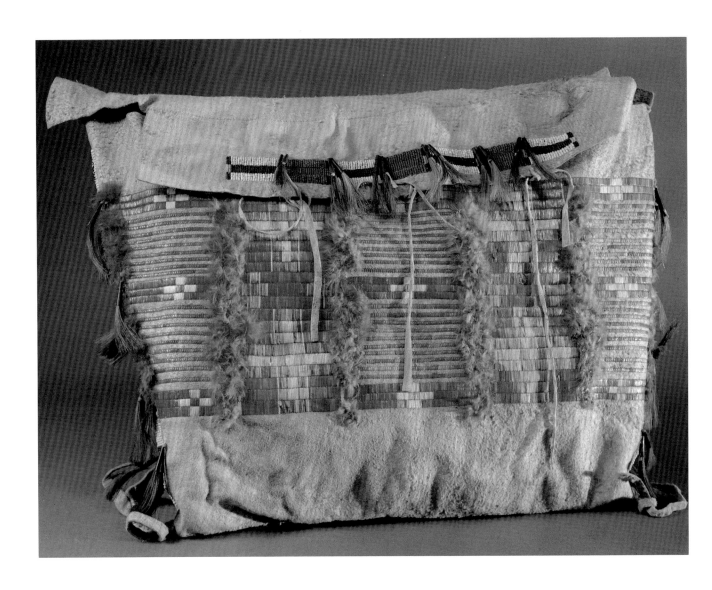

Saddle Bag (Sioux)

39-30-10/18204 Width 54 cm.

This general utility bag would have been suspended from the
pommel of a saddle. It is made of a single piece of deerskin folded
over and stitched up the sides. The top flap is formed by sewing
on a separate piece. Decoration consists of a combination of
quills, beads, hair and feathers, colored by commercial dyes. This
object was collected in 1901. T1250

Dress (Oglala Teton Sioux)

03-1-10/62733 Length 145 cm.

This dress is made of blue wool cloth decorated with a bodice of
dentalia shells which came from the Pacific coast and were
obtained in trade from Indians of the Plateau. According to
catalogue records, this dress belonged to a daughter of Crazy
Horse, a famous Oglala chief. T1226 (R)

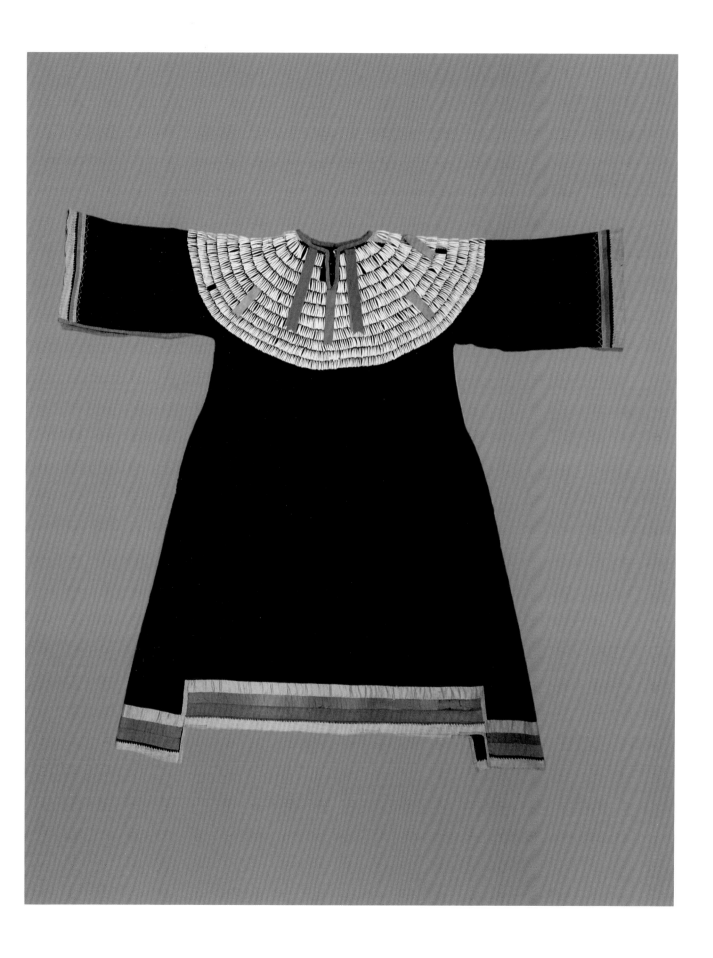

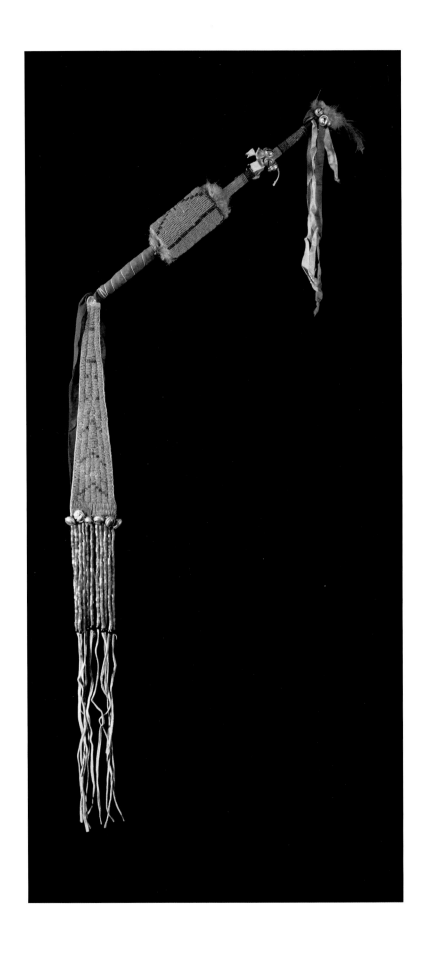

Rattle (Arapaho)

39-30-10/18241 Length 73 cm.

This rattle, collected in 1901, is constructed out of a tin can attached to a wooden handle. Threaded beads have been wrapped around one end of the handle. The can has a beaded hide cover. Feathers dyed orange, ribbons, and brass bells provide additional ornamentation. T1275 (L)

Moccasins (Oglala Teton Sioux)

19-17-10/87391 Length 27 cm.

These moccasins have beadwork on the soles as well as on the uppers. Many people refer to these as "burial moccasins" but this is only part correct, since historic photographs reveal that they were also worn by the living. Museum records attribute them to the Oglala, but the beadwork is reminiscent of the northern Blackfoot style in which squares or oblongs are repeated to make up the overall design. The archaeologist Samuel K. Lothrop collected this pair at the Pine Ridge Agency in 1915. T1283

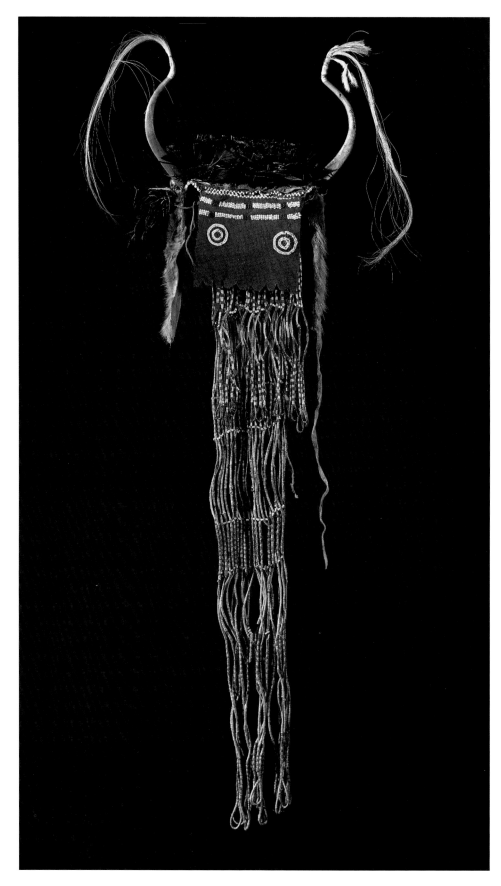

Man's Society Headdress (Mandan or Hidatsa)

87-11-10/40898 Height 89 cm.

This headdress was worn by members of the Buffalo Bulls, a warrior society, during the Buffalo Dance.
This object was collected in 1886, but the porcupine quill-wrapped streamers are characteristic of
Plains costume and equipment of the early to mid-nineteenth century. T1273

Arctic and Western Subarctic

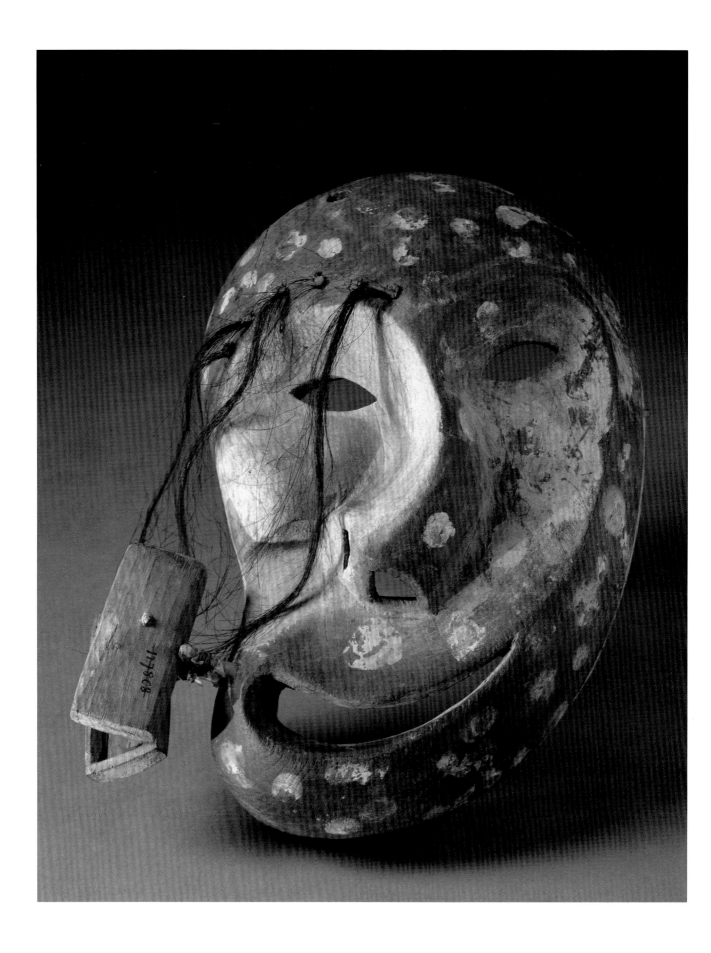

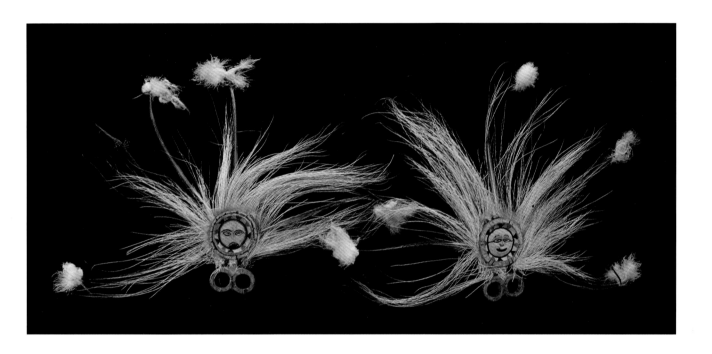

Dance Mask (Southwest Alaska Eskimo)

88-51-10/50002 Height 22 cm.

This mask was collected at Ugashik, which might suggest it is
Pacific Eskimo; however, it is more characteristic of carvings
produced by the Southwest Alaska Eskimo. The twisted face
relates to a *tunghat,* one of a number of evil spirits which control
the supply of game animals. When shamans underwent
transformations, they normally suffered seizures; the contorted
faces may be related to the muscular distortion which resulted.
The shamans are believed to have made trips to other lands and
even the moon at such times, so it is not surprising to see lunar
features (the white dots in combination with the twisted face) on
this mask, especially as *tunghats* were thought to have lived in the
moon. A *tunghat* probably controlled the spirit of the seal
contained in the attached wooden box. W. J. Fisher, an employee
of the Coast Survey on Kodiak Island, collected this mask in
1887. T1269 (L)

Finger Masks (Southwest Alaska Eskimo)

06-25-10/66313 Width 30 cm.

Women often wore finger masks during religious dances. This pair
displays *inua* faces in their center. *Inuas* are the spirits of animate
and inanimate objects. The halo of caribou hair symbolizes the fur
ruff of a parka. The feathers and down are possibly from old squaw
duck. The mask with goggles frowns on one side (a woman) and
smiles on the other (a man). The mask on the right frowns on
both sides and is probably symbolic of an animal. These objects
were collected at Cape Vancouver in 1905. T38

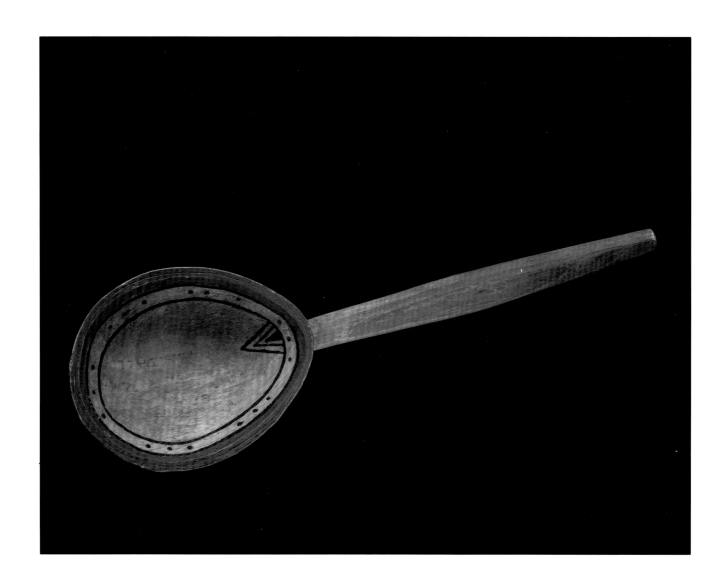

Wooden Ladle (Ingalik)

88-51-10/50122 Length 27 cm.

The black and red pigments commonly used on these ladles were fixed with blood so that they would not rub off easily. This one was made by the Ingalik on the Lower Yukon River, but such items often filtered downstream to coastal Eskimo groups. William H. Dall collected it before 1888. T1270

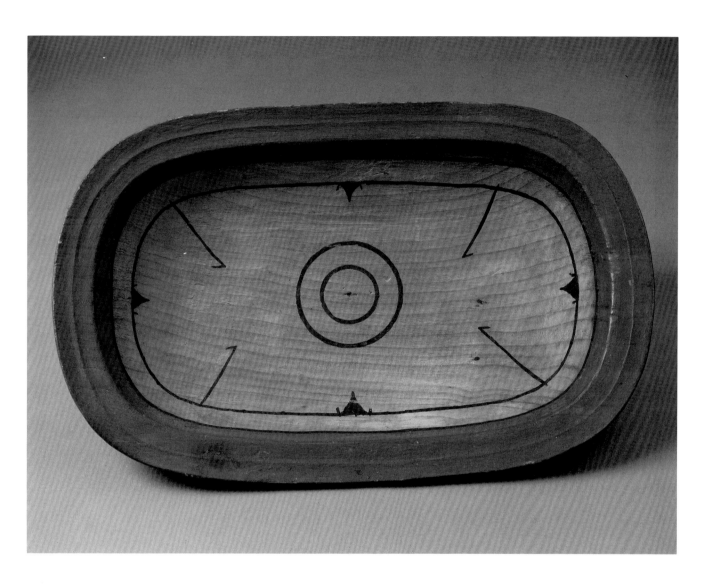

Wooden Bowl (Ingalik)

88-51-10/50123 Length 25 cm.

This lightweight food dish, carved from a single piece of wood, was collected from among the Ingalik Indians of the Lower Yukon River by the geographer and naturalist William H. Dall before 1888. Each woman would have had a stack of such bowls in the corner of the house for serving and eating food. The bowls were either made by her husband, or received in exchange from Indians farther upriver. The red and black designs related to family ownership or, if mythical creatures were shown, had symbolic significance. T1271

Seal Decoy Helmet (Pacific Eskimo)

69-30-10/64700 Length 26 cm.

This helmet, a naturalistic carving of a seal, came from Kodiak
Island. The hunter would have worn it while hiding behind a rock
with only the helmet itself exposed in order to attract the live
seals. It dates prior to 1869, as it was collected in that year by
Captain Edward G. Fast while he was stationed in Sitka, Alaska.
The style of the brim may have been influenced by European hats
of the period. T918

Doll (Copper Eskimo)

21-14-10/87689 Height 31 cm.

This doll is dressed in a woman's costume. Dolls were made by
young girls as toys, but the act of creating the clothing was a
valuable education in itself. The process of cutting the leather into
patterns, and sewing the pieces together, developed important
skills. T1241 (R)

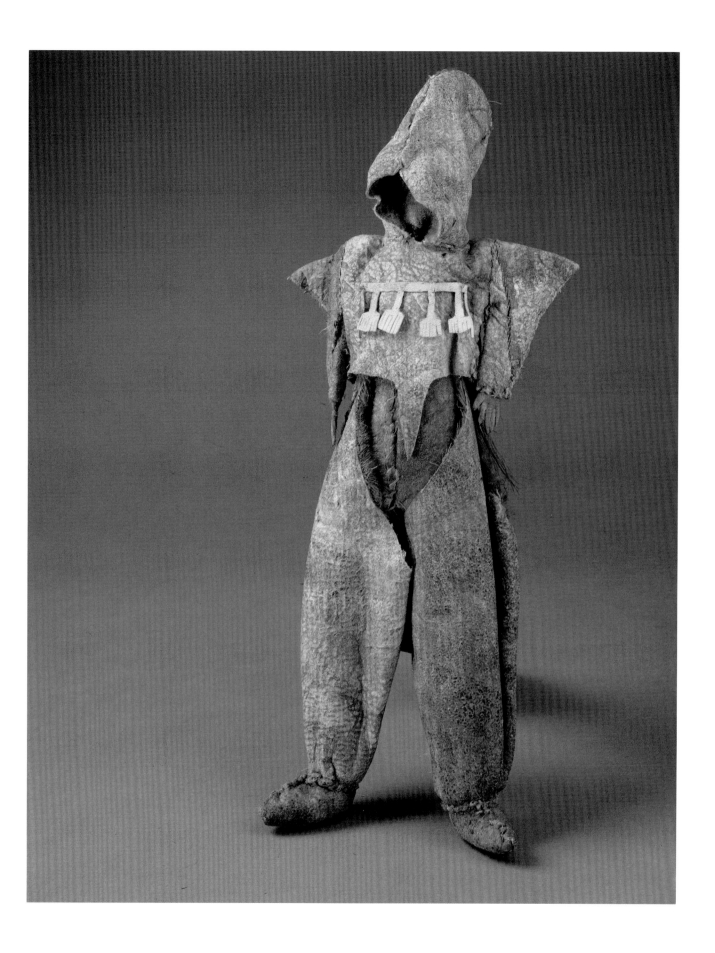

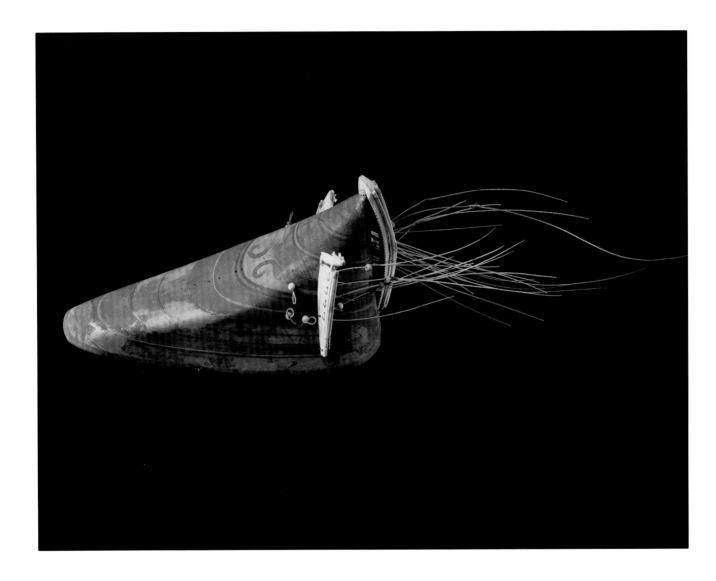

Man's Hat (Aleut)

69-20-10/1263 Length 93 cm.

This long-billed hat is typical of men's headgear in the Aleutians
and southwest Alaska in the first half of the nineteenth century.
The wood, probably spruce, has been bent into shape and then
stitched at the back. Sea-lion whiskers bearing blue, white, and
green Russian trade beads are attached to ivory wing pieces. The
caribou effigies at the top of these wings are unusual, because sea
hunting equipment rarely depicts land animals. This object came
to the Peabody Museum in 1869 from the Boston Marine Society.
T558

Man's Visor (Aleut)

69-30-10/1612 Height 47 cm.

This visor is made of spruce, with either a painted bark or paper
cover glued to its surface. Wool tassels and braided loops were
added as decorative touches. The chin piece is made of braided
sinew. The sea-lion whiskers occur on only one side of the visor.
Had they occurred on the other side as well, the right-handed
owner would have snapped them off while hunting. Captain
Edward G. Fast collected this object in 1867-1868 while stationed
in Sitka, Alaska. T1242 (R)

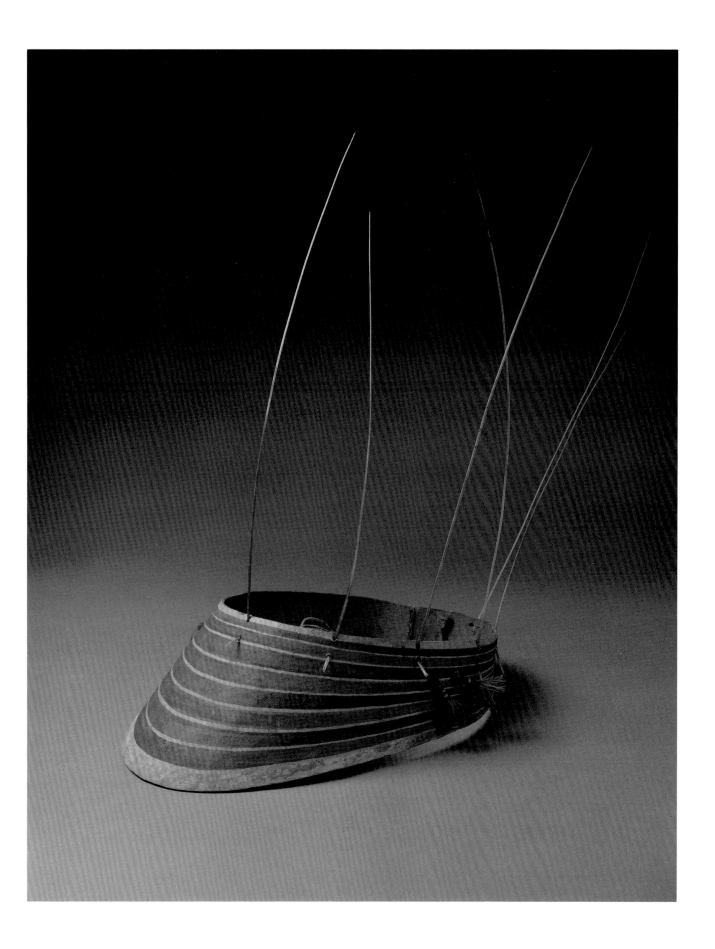

Knife (Western Athapascan)

31-32-10/K119 Length 38 cm.

This type of knife, with a handle that ends in flaring voluted antennae, was widely distributed in the Alaskan interior and the Mackenzie River Delta region. Native copper was the preferred material for these double-bladed knives but once commercial steel appeared, indigenous metal was quickly replaced. T1289

North West Coast

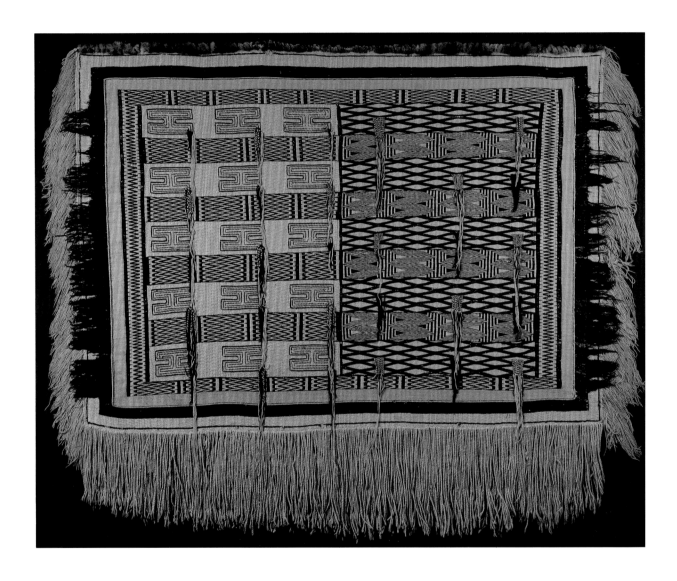

The "Swift" Blanket (Tlingit or Tsimshian)

09-8-10/76401 Width 179 cm.

There is no other textile tradition in the world like that of Chilkat blanket weaving, and the "Swift" blanket is the earliest example in the United States. It was collected by Captain Benjamin Swift of Charlestown, Massachusetts, about 1800. Chilkat blankets were worn by tribal leaders only on ceremonial occasions and were a sign of great prestige. Much of their value came from the expense involved, because manufacture required many months of labor. Male artists were commissioned to develop the designs, but the actual weaving was done by women using simple upright looms.

One end of the warp (vertical fiber) was secured to the top beam of the loom, while the other end hung free. The warp of this blanket is made of shredded cedar bark wrapped with mountain goat wool. The weft (horizontal fiber) is fashioned out of handspun, native-dyed, mountain goat wool. The geometric designs on eighteenth century Chilkat blankets are closely related to those seen on later baskets, whereas nineteenth and twentieth century Chilkat blankets favor stylized crest animals. T849

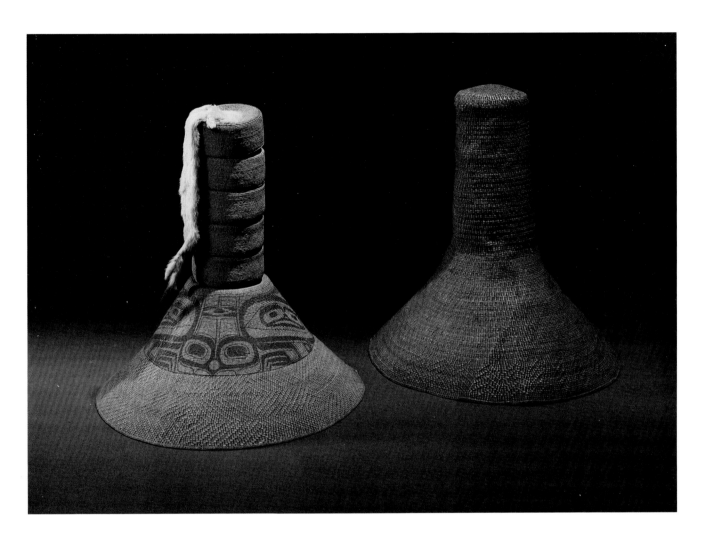

Basketry Hat and Cover (Tlingit)

Left 04-10-10/62829 Height 28 cm.

Right 04-10-10/62830

Crest hats were only used on ceremonial occasions, and at all other times they were stored within basketry covers. This northern crest hat is made of spruce root, in three-strand plain and skip-stitch twining. A pattern of concentric diamonds resulted from the latter technique. The five basketry cylinders, often called potlatch rings, surmounting the hat are prestigious emblems. An ermine skin hangs from the top ring. The hat and cover date to the early nineteenth century. T56

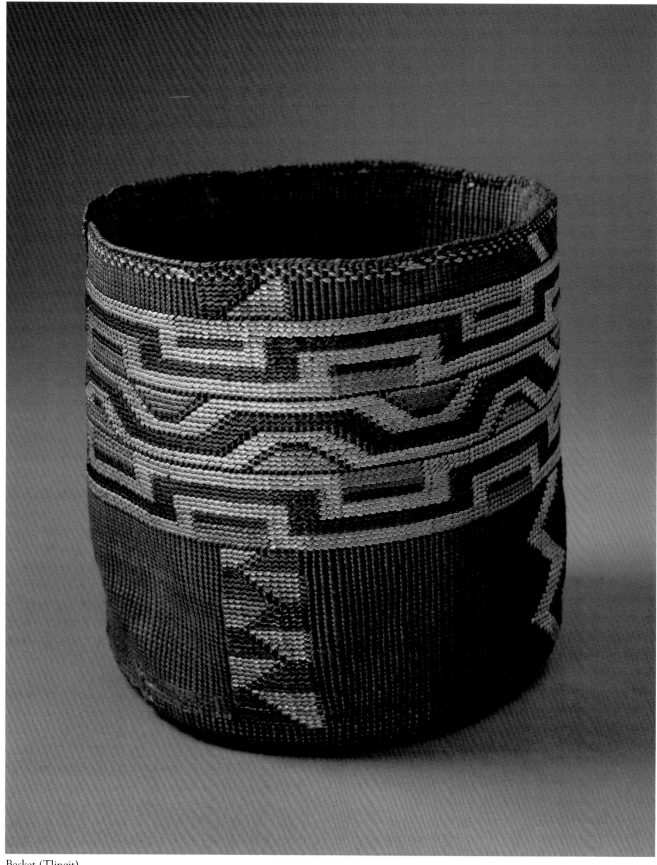

Basket (Tlingit)

31-63-10/K87 Height 16 cm.

This small, twined basket is made of spruce root with false embroidery. Evidence of folding indicates it was meant for native use. The vertical bands on the lower half of the basket are from an old pattern and it probably dates to the mid-nineteenth century. T1247

116

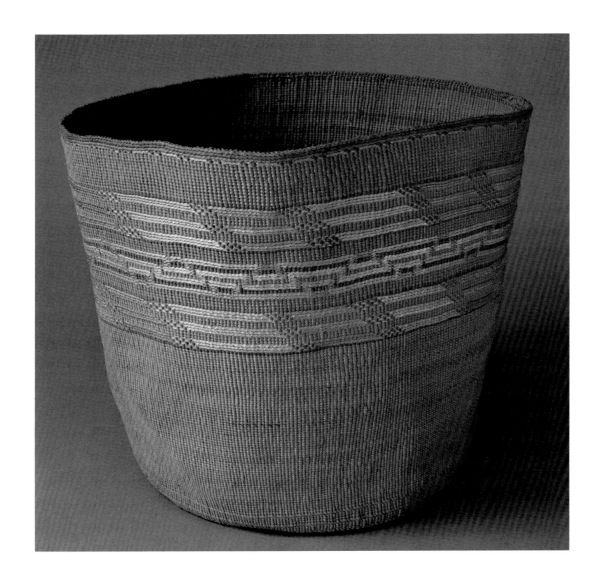

Basket (Tlingit)

11-2-10/83824 Height 30 cm.

This once creased and folded basket was made for native use. Because the spruce root would stiffen, these baskets were damped prior to opening and reuse. This basket form is often referred to as a berry basket, but it could have had multiple uses. It was collected about 1878. T1244

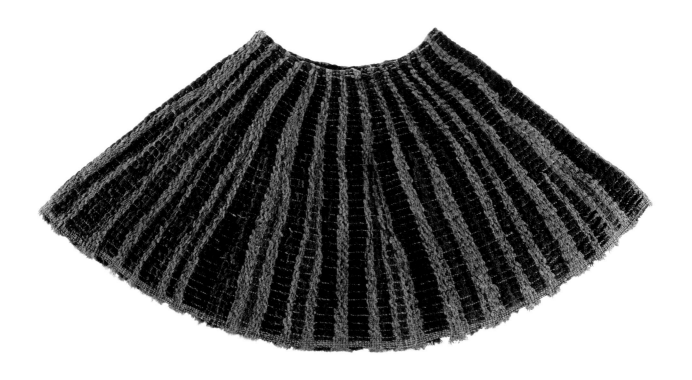

Twined Cape (Westcoast or Kwakiutl)

974-05-10/52148 Width 80 cm.

Of unknown provenience, this cape is clearly a copy of the
circular capes made by Westcoast and Kwakiutl Indians, but wool
was used instead of strips of cedar bark. The wool was unravelled
from Hudson's Bay Company trade blankets, and then twined
into this traditional form. T1225

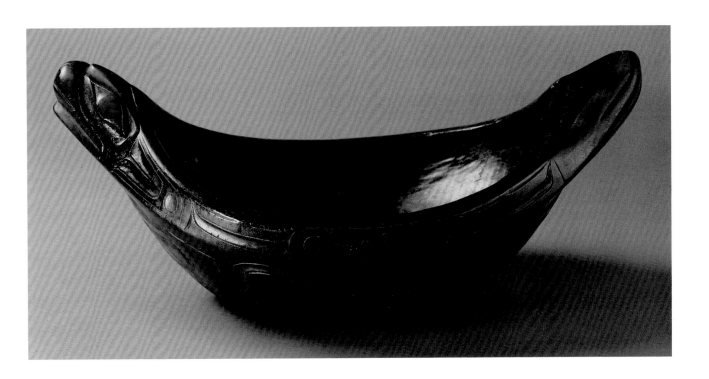

Seal Bowl (probably Haida)

17-62-10/87246 Length 34 cm.

Indians of the northern Northwest Coast hunted seal for skin,
meat, and oil which was particularly valued. This vessel was
meant to contain the oil. The seal effigy is posed in a stretched
position, as if it were basking in the sun. It was collected by naval
lieutenant George T. Emmons on the Queen Charlotte Islands
before 1917. T1252

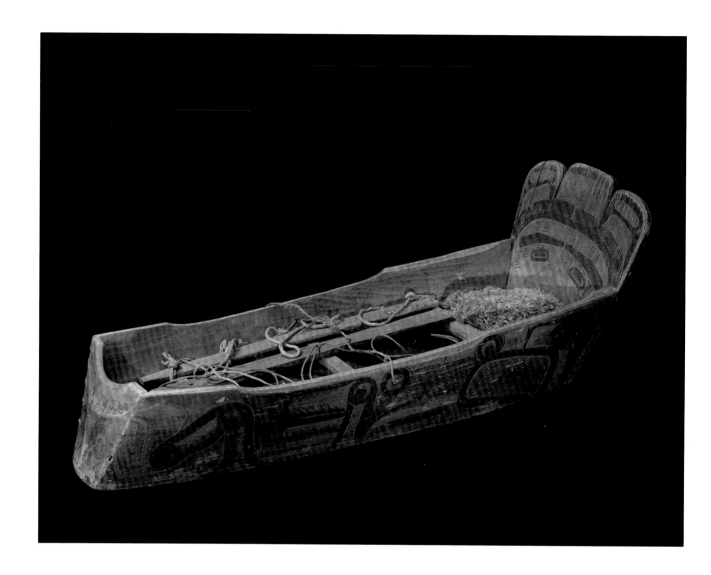

Cradle (Kwakiutl)

05-7-10/65626 Length 93 cm.

This late nineteenth century cradle is typically Kwakiutl in form. The baby would have lain on the rails, the space beneath having been designed for air circulation. The bundle of cedar at the top of the cradle is a head pad. A series of loops made of commercial cloth occur along the sides, and a long line would have been sewn back and forth between these loops to secure the child. The painted patterns may relate to family crests. The head, leg, claw, and tail of a raven appear along the sides, and a human face is shown on the headrest. This object was collected by Grace Nicholson in Alert Bay on Vancouver Island. It came to the Peabody Museum in 1905. T1281

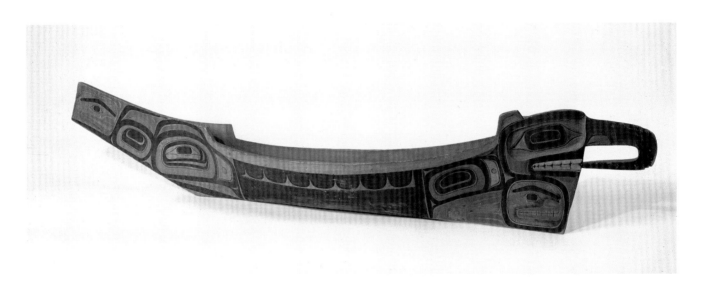

Canoe Model (Tlingit or Haida)

69-20-10/1243 Length 117 cm.

This vessel style is called a "head canoe." It is only known from models, as the form went out of use in the early nineteenth century. This model is probably made of yellow cedar and has an unusual beak, perhaps relating to a thunderbird, although it could signify any of a number of creatures. The rest of the design is also ambiguous. The grooves around the interior share similarities with those seen on the interiors of wooden grease bowls. Samuel Topliff collected this object about 1849, and it came to the Peabody Museum through the Boston Marine Society. T1243

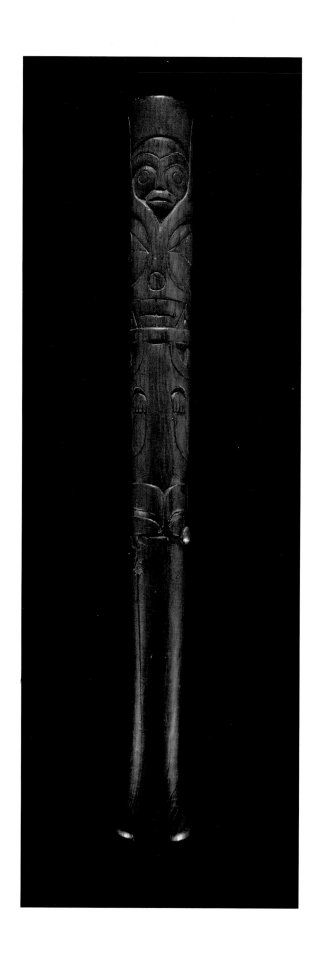

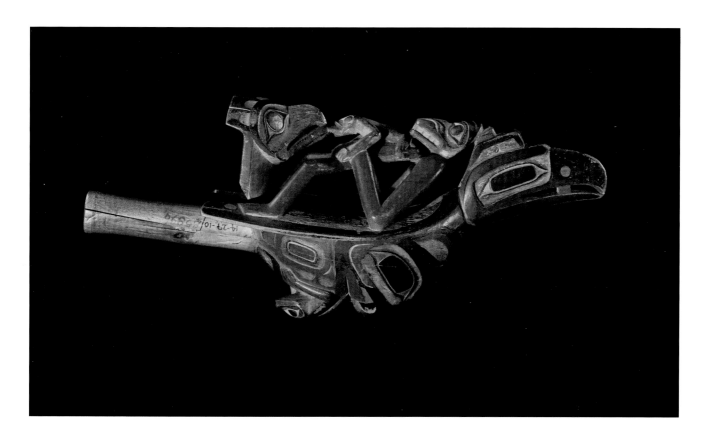

Singer's Baton (Kwakiutl)

14-27-10/85895 Length 36 cm.

During certain ceremonies batons were struck against planks to keep time and to guide the singers. The shape and decorative styling of this baton identify it as Kwakiutl. It was collected by naval lieutenant George T. Emmons on northern Vancouver Island before 1914. T1245 (L)

Chief's Rattle (Northern Northwest Coast)

14-27-10/85896 Length 31 cm.

These objects are usually referred to as "raven rattles" because normally the raven is the principal motif. Here, the main creature has a hooked beak and is probably a hawk or eagle. The figures on the back of the bird include a human effigy with a wolf's head, a frog, and a grouse-like bird. On the breast is a hawk's head with a frog. These rattles were carried by chiefs during dances and contained lead shot or glass beads. This particular one, collected by George T. Emmons, dates between 1850 and 1880. The Museum's records suggest it is Tsimshian, but it is probably Haida or Tlingit. T1246

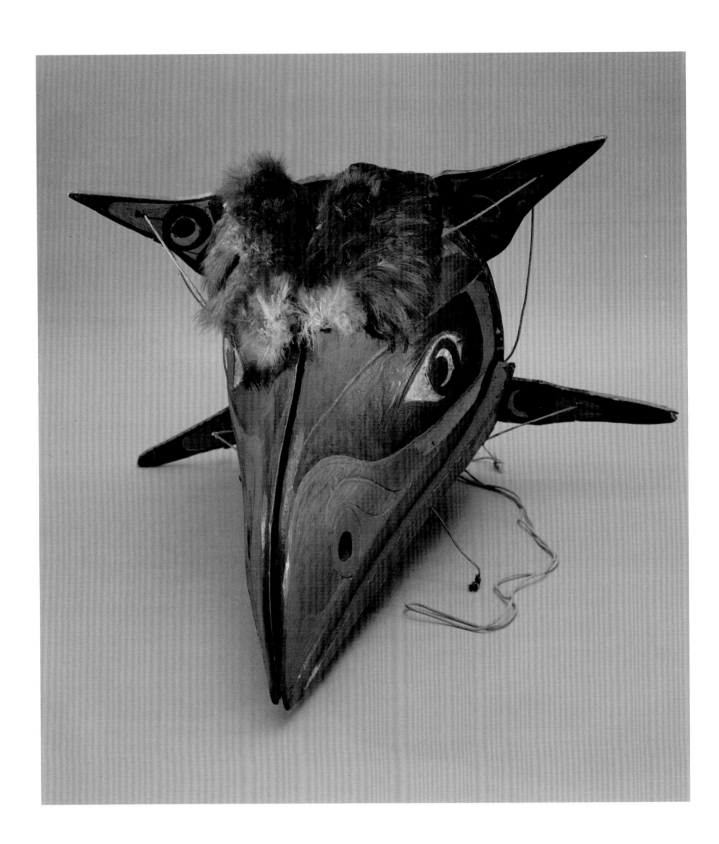

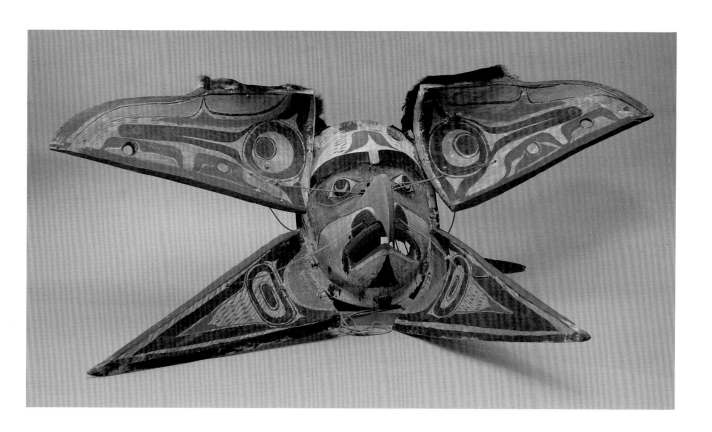

Transformation Mask (Kwakiutl)

17-17-10/87190

This is a mask within a mask. As the raven image opens, it splits into four parts forming the rays of the sun, and an inner anthropomorphic face with a great hooked beak appears. The meaning of the mask is ambiguous. It could either dramatize a transformation, such as that of a clan ancestor, or it could be a combination of different crest figures. The collector Charles F. Newcombe acquired it at the village of Tsatsichnukwumi on Harbledown Island in 1917. (Mask closed, left) T1282

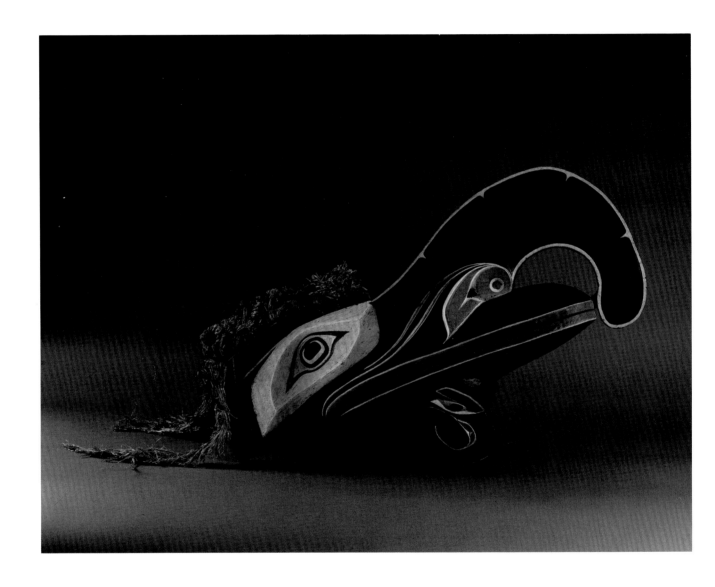

Hamatsa Crooked-Beak Mask (Kwakiutl)

17-17-10/87202 Length 90 cm.

The most fanciful of the *Hamatsa* masks is that of the Crooked
Beak, representing a voracious mythical bird, believed to be a
supernatural associate of *Bakhbakwalanooksiwey* the man-eating
spirit. Its appearance at the Winter Ceremonial dramatized the
power with which the *Hamatsa* had been possessed. This great
mask was worn on a squatting dancer's forehead, the weight of the
beak being countered by a strong harness that reached down
behind the back and tied under the arm. The dancer would have
hopped about in a squatting position, while manipulating the
hinged jaw. He therefore had to be strong and experienced, as a
mistake or slip was a serious breach of the Winter Ceremonial.
C. F. Newcombe collected this mask at the village of Gwai'i,
Kingcome Inlet in 1917. T720

Clan Mask (Kwakiutl)

17-17-10/87191 Height 27.9 cm.

This mask represents a clan ancestor who came to earth in a
transitional state as part bird (a kind of thunderbird) and part
man. Charles F. Newcombe collected this mask in 1917 at
Tsatsichnukwumi on Harbledown Island. T1207 (R)

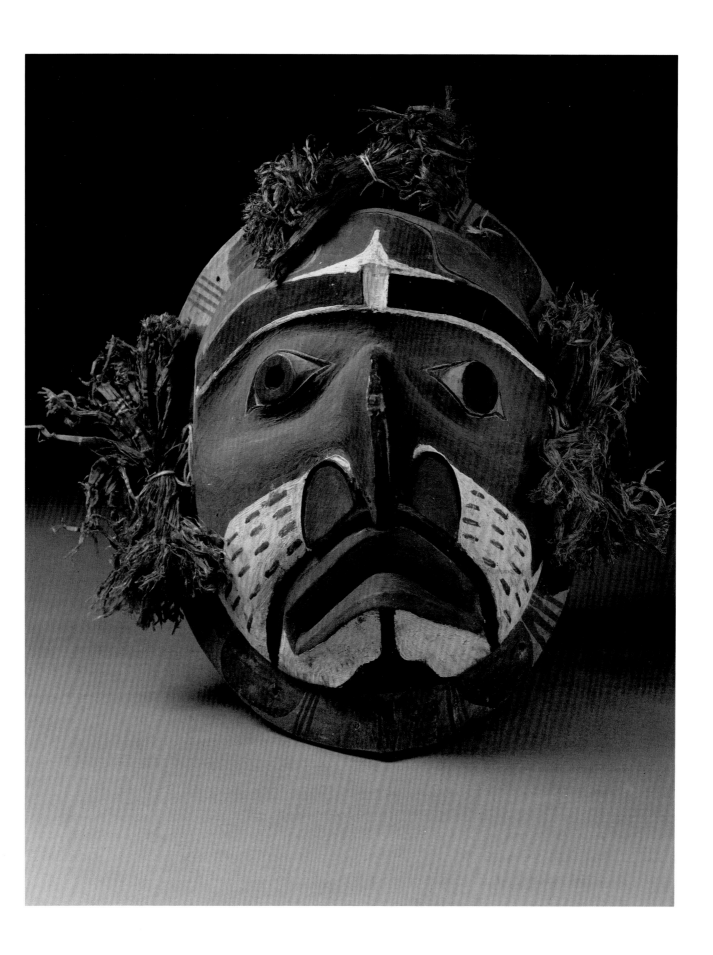

128